Images of America
Town of Olive

ON THE COVER: The Dutch settlers who came to this area called it the Blue Hills and set up small log cabins from the timber on their land. Later, once the land had been cleared of Hemlocks for tanning, farming became their main occupation. They were self-sufficient people planting what they would need to sustain themselves and their animals. It was an area where bluestone was quarried, and with the advent of the Ulster & Delaware Railroad, a boardinghouse industry thrived. These were the early years of a town that would eventually experience a profound loss of everything they had labored for and created. A town that would reinvent itself by necessity, transform, and move forward. (Courtesy of the Olive Free Library Archive.)

IMAGES
of America

TOWN OF OLIVE

Melissa McHugh
Foreword by Kate McGloughlin

ARCADIA
PUBLISHING

Copyright © 2024 by Melissa McHugh
ISBN 978-1-4671-6169-5

Published by Arcadia Publishing
Charleston, South Carolina

Printed in the United States of America

Library of Congress Control Number: 2024934668

For all general information, please contact Arcadia Publishing:
Telephone 843-853-2070
Fax 843-853-0044
E-mail sales@arcadiapublishing.com

Visit us on the Internet at www.arcadiapublishing.com

To my husband, John, and my children Brian, Isabella, and Olivia for your support and encouragement. To all the wonderful people from the town of Olive whom I have met and who have shared their stories and history with me. Finally, to the people of Olive who came before us and settled and created this beautiful community; I dedicate this book to you.

CONTENTS

Acknowledgments		6
Foreword		7
1.	A Town is Born	11
2.	The Ulster & Delaware Railroad and the Boardinghouse Industry	25
3.	One-Room Schoolhouses in the Town of Olive	47
4.	New York City Needs Water	61
5.	Building the Ashokan Reservoir	85
6.	A Town Moves Forward	101

ACKNOWLEDGMENTS

A book like this that explores the history of a town cannot be written in isolation. I have had the wonderful opportunity to meet with so many amazing people throughout this project. First and foremost, I would like to thank Janette Kahil for being my fact-checker and historical guide. Her help during this process was immeasurable. Kate McGloughlin graciously agreed to write the introduction for this book, and the love she has for our community is evident in her beautiful prose. While researching and curating *A Town Shaped by Water*, I had the great fortune of meeting and discovering the histories of many local people and families: Donnie Beesmer, Jack Bierhorst, Florence Eckert Guiliano and Marty Guiliano, Barbara and John Parete, Raecine Shurter, Rodney Sage, Primo Stropoli, and Eric Winchell. Thank you for sharing your memories, pictures, and stories. Finally, I would like to thank my family for their support, encouragement, and willingness to listen to many, many Olive history tidbits. Unless otherwise noted, all the images in this book were obtained from the Olive Free Library Archive.

FOREWORD

Things change.

We say those two powerful words in our household a few times a week, usually when one of us gets stuck in some woeful place. We reassure each other that, in fact, things do come to pass, not to stay. Though humans are wired for change—current neurobiology says we change a billion times a minute—to my recollection, I have never bumped into anyone in my hometown—the wonderful town of Olive—that has ever wholeheartedly embraced change, unless, of course, they instigated it.

If you stay in a place long enough you will notice changes, some subtle, some pretty severe.

We used to go to the dump. Then the landfill. Then the recycling center. Now we go to the transfer station. Same place. All that has changed there is the name and the sweet guys who work there. I miss Sol, too—everyone does.

When I was a little kid, the fire siren in the town of Olive blew once in a while. Ethel Gray got the call, ran over to the firehouse, and wrote the address of the fire or accident on a small slate board. Whoever did not fit in the first fire truck we had back then, made their way as quick as they could to help their neighbor in need. The siren sounds several times a week now; more calls, more alarm malfunctions, more floods in a lot more basements. Our volunteers leave their homes and jobs and horseshoe tournaments, birthday parties, and the warmth of their beds on really cold January nights a few times a week—sometimes a few times in one day.

Folks that are newer to town find it hard to believe that when I was growing up here, in my own little hamlet of Olivebridge, there were three places to buy gas within a mile of my home! Ethel Gray's, Ollie Crawford's, and Nelson Boice's. The "business district" on Route 213, County Route 4 to some, ran from the Methodist church to Davis Corners, where my family homestead still stands. (Though we were granted property here 12 generations ago, that house was built in 1808— six generations back from me.) As six-year-olds, my twin brother Michael and I regularly walked to Ethel's for Slim Jims. (There is a story about us finding our way there as toddlers, with Gordon "Chee Chee" Miller pulling his dump truck sideways to stop traffic so we did not get creamed, but I digress.) By the time we had bikes, we were riding them with LeAnne Avery and Robbie Shultis to Ollie Crawford's Mobil Station to put air in our tires. Next, we would ride on to Nelson and Nettie Boice's General Store for an ice-cream soda at the counter and maybe buy a bag of nails to finish our tree fort. Finally, we would visit Joe the butcher for, perhaps, a free slice of bologna or salami along with a squeeze of the cheeks and a big kiss from Rose. Folks, it was paradise.

At that time, if we were going out to dinner, it was either to the firehouse, the Odd Fellows Hall, or the church fellowship hall. The time of year determined our outings, and though there seemed to be the same cast of characters at each place (at least in Olivebridge), you went to the Methodists for the chicken BBQ in the summer (remember Janie Silkworth standing on a step stool in the kitchen up to her elbows in the best coleslaw in the world?), the Odd Fellows for roast beef dinners in the fall, back to church for Election Day oyster stew and ham supper (yes, you read that right), and off to the firehouse in the winter time to support the Boy Scouts at their spaghetti suppers and

pancake breakfasts—Rosie and Bob Burgher made sure there was plenty of everything, always.

If it was a dance you wanted, it was square, and it was at the Odd Fellows. In later years, waltzes, polkas, and two-steps happened at the firehouse and under the new pavilion at Davis Park with Don Barringer and the Moonlighters strumming favorites.

The memories mentioned here echo tens of thousands of recollections from other "townies" who have lived and loved in the "Town of O" these past 200 years or so. It is with a full heart that I write this love letter to my town and my beloved neighbors. They know that I am no expert or historian, and in fact, some might even remember that I could not wait to get out of here when I was 18. In the 1960s and 1970s, and probably in other eras, Olive was a great place to be a kid or a "settled" person. It was, however, rough on the ramblers and ruffians who were ready to experience a full-throttled, full-throated, rip-roarin' life. Olive seemed too small, with too many eyes and ears and way too many wagging tongues.

I had no idea that one day I would pine for that closeness, that sense of knowing and concern, and long for those days of catching the news at Ethel Gray's Store, or Skin's if you were a West Shokaner, or Johnny Nichols or Tetta's in Krumville and Samsonville, or the D&M Market in Ashokan, or from the Boiceville Market—the little one that Mrs. Sheeley tended, not the big supermarket—or miss standing in line with my sweaty teammates at Dino's Kwik Stop in Boiceville while waiting for our free-after-game cone. What generosity existed! Those small businesses were all run by brave, regular people, trying to keep up with competitive Kingston prices and soaring speed limits on Route 28 that encouraged tourists to pass them by. I am moved by Primo Stropoli's visionary determination to remain and expand as a third-generation store owner at Tetta's Market in Samsonville, which thrives at this writing, and Bread Alone, once a mural-faced, cinder block bakery, now an award-winning, carbon-neutral, world-class bakery and a second-generation, family-owned café.

Every hamlet has its charms here in Olive. I know that a Samsonvillian, a West Shokaner, a Krumvillian, a Shokaner, a Boicevillian, an Ashokaner, and Brown's Stationer all have their versions of these stories, too. Some of those hamlets actually had taverns and restaurants, and at one time, the town of Olive had more gin mills than it did churches. Those stalwarts who remain, the Boiceville Inn, the Country Inn, and Snyder's Tavern, all have a warm place in my heart and an illustrious catalog of great stories vaguely etched in my memory, too.

In this volume, we will look at the "change of all changes"—life before, during, and after the building of the Ashokan Reservoir—the biggest alteration to our landscape and our cultural life to come along since these eroded plateaus were formed and High Point had the Wagon Wheel Gap sliced out of her during the last glaciation. We hope to leave a lasting record of why some of us that bloomed where we were planted, stayed here and made this place so attractive that others came and made it their home. Before the town was formed, many families had already settled in the Esopus Valley and had what was essentially a subsistence economy: growing, milling, weaving, carding, heading, extracting, manufacturing, trading, and repairing. Most farmers, millers, and tradesmen were also public servants—just like today.

I know they used to call us "Low Tax Olive," but some of our families actually landed here way before the town was incorporated or the roadbeds were made. And if you came here for low taxes, I hope you stayed here because your neighbors were kind or you became smitten with the majesty of Bert and Ann Liefeld's fields or fell in love with the hard rolls at the Pine View Bakery. Maybe it was a summer ritual of jumping into the freezing, holy water at Blue Hole or Red Rocks or Hobie's Hole or the Esopus at Chimney Hole. Maybe you found one of our sweet, little churches and became family or have joined the fire department, women's auxiliary, or rescue squad. I hope so. Or maybe you love the beating heart and lungs of our town—our amazing Olive Free Library; Davis, Shokan, and Tongore Parks; and the town pool—as much as I do.

Things do change, but one thing that does not seem to change is how much the citizenry here seems to love their hometown, from the very first meeting when they first elected public servants and laid out the South Road (only a few of us still call it that; many of you call it Krumville Road and still others refer to it as—gasp!—2A). It might interest you to know that there were 37 citizens

8

at the meeting that night, in April 1824, and that they voted to pay taxes and put aside $200 "for the support of the poor for the ensuing year." They took care of each other and built roads to get to each other's farms that night. They loved their little community then too.

On the occasion of our bicentennial as a town, the marvelous staff at the Olive Free Library, under the creative and watchful eye of archivist and now library director Melissa McHugh, installed an outstanding exhibit in the library museum. The exhibit detailed our town's illustrious history, getting hamlet-specific details from old-timers with stories that have been archived for posterity. You do not have to have lived here for generations to get a kick out of knowing what used to go on in "the best little town by a dam site," and Melissa has done an incredible job at researching and finding the right people to speak with to take a deeper dive into the nooks and crannies of each of the hamlets in the town we love so well.

I have yet to serve my town in the many ways my ancestors have, though I do hope this offering spurs further conversation and brings back some fond memories to you, dear reader. Upon my own, deeper reflection, I see where maybe our attitudes have not always reflected the warmth that truly exists here, and at times perhaps we have not shown the best side of ourselves to others. I have sometimes wondered if at least some of our reticence stems from the hole that was carved out of the middle of our town long ago, displacing families but providing water to quench the thirst of our neighbors to the south of us in New York City. Over time, that hole has been filled with a life-giving beauty that we now never tire of, despite ourselves. Hooray for the resilient neurobiology that makes this possible—in fact, hooray for us! Can we ever consider ourselves whole, then?

May we move forward standing on the shoulders of both the lionhearted and the soft-spoken, the most wise of our ancestors, beloved friends, and the quirky characters that came before us in the town of Olive. May we sustain her—rooted in rural—being stronger for ourselves and softer toward others while revering our beautiful farms and fields. And may we reserve a few swaths of land where our kids and their best friends might come back and live and leave something behind for the next wave of frog-jumping and egg-toss champions to thrive in and earn bragging rights for years to come at Olive Day.

I hope to see you there for many years.

—Kate McGloughlin
Davis Corners
Olivebridge, New York

One

A TOWN IS BORN

Property was being purchased in the Blue Hills in the early 1700s. Pictured is a surveyor's map of the property of Joris Middagh, one of the earliest settlers in the town of Olive. The survey was being done at the request of Capt. Charles Brodhead, whose name was given to Brodhead village. The Brodhead family were early settlers of both Marbletown and Olive. (Courtesy of the Winterthur Library, Garden, and Museum.)

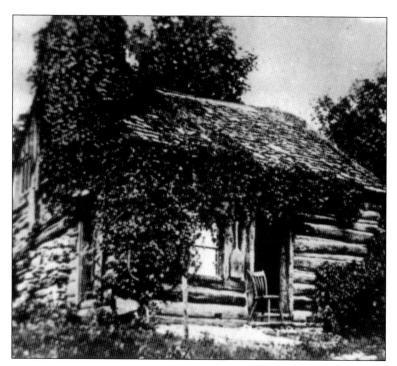

On October 15, 1704, Charles and Richard Brodhead, Joris Middagh, Thomas Jansen, and Cornelius Bogart were given 100-acre land grants. The land at that time was still a part of the town of Marbletown and is now located under the upper basin of the Ashokan Reservoir. Pictured is an early log cabin built in 1808 on the Winchell Farm.

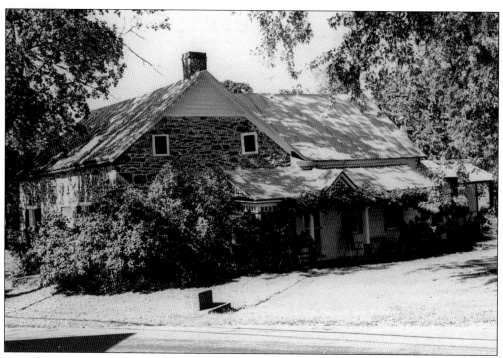

According to research done by Vera Sickler, a log cabin was built by Joris Middagh in 1740 in Olive City. One of the first houses in Shokan was built by Andrew Hill in 1797. It was not until the plank road (Kingston and Middletown Turnpike) that more buildings were erected in the area. Pictured is the home of Gordon Craig, the town's first supervisor. It was built in 1800.

Tensions between the Tories and Native Americans against the Patriots were increasing, and several forts were built in the area, one located in Marbletown and another in Shandaken. They were too far away to support the settlers; therefore, a fort was constructed in Shokan. It was located near the Bushkill where the Butternut Creek is located. Later, the Andrew Hill House was constructed at this site. In later years, it was known as the William Every Farm and is now under the reservoir near Longyear Road.

Even with the construction of the fort, hostilities continued, and in 1781, Native Americans came to the home of the Bush family; finding Thomas Bush, a patriot, was not at home, they abducted three of his sons. The boys were separated and adopted by different tribes. The boys were eventually located and reunited; however, Isaac left the area to live in Buffalo, while Cornelius and Stephen remained in Olive.

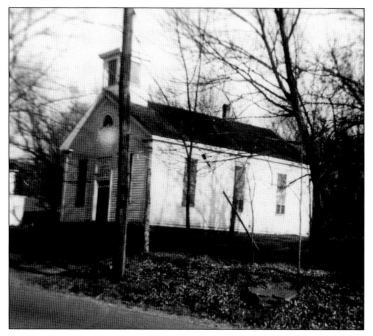

The first Old School Baptist Church was built in Olive City in 1808, which was still, at that time, in the town of Marbletown. In 1851, the members decided to build a church closer to where most of the townspeople lived. The new church finally opened in 1857; Elder Jacob Winchell was the minister and Henry Bogart, William Brown, and Samuel Elmendorf were the trustees. The property was deeded to the church from Jane and Abram Du Bois.

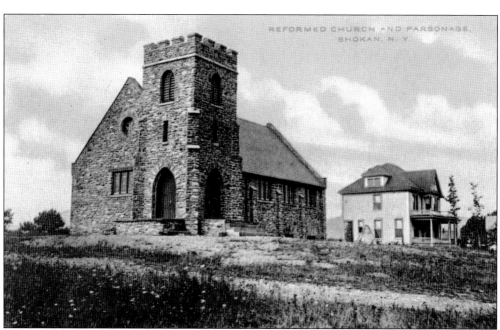

The first Dutch Reformed Church in the area was built on Uriah Hill's property, which in 1800 was still part of the town of Marbletown. The elders of the church were Andrew Hill, Thomas Garrison, and Conradt Du Bois. This church was demolished during the construction of the Ashokan Reservoir. A new church was constructed on September 14, 1913, on Church Road in Shokan.

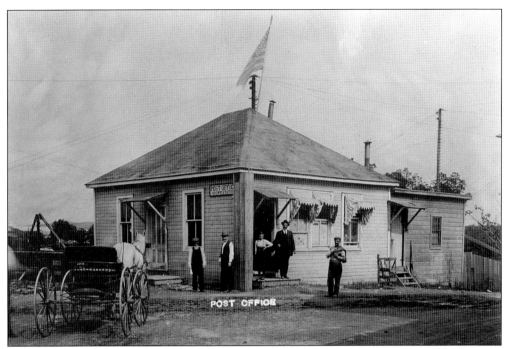

The first post office in the town of Olive was located in Tongore in 1830. It was eventually called the Olive Post Office, and later, it was moved to Beaverkill. The Shokan Post Office was initially named the Caseville Post Office. Pictured is an early post office at Brown's Station.

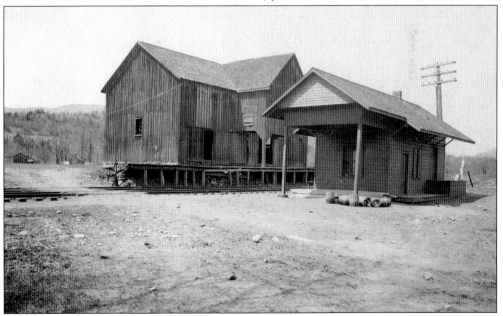

Prior to the construction of the Ashokan Reservoir, Boiceville was located closer to where the rail trail is today. It was a very small village with the Patchen Tannery, Excelsior Mill, a couple of houses, and a post office. The tracks of the railroad lead right up next to the mill for easy transport. Many of the local people brought their logs there to be milled. Above is the Patchen storehouse in old Boiceville next to the railroad station. (Courtesy of DEP Archives, Digital Image ID p001308.)

One of the most prevalent industries in the area was farming. Kate McGloughlin's family farmed their land for seven generations, beginning with Charles Davis and ending with Michael McGloughlin. (Courtesy of Kate McGloughlin.)

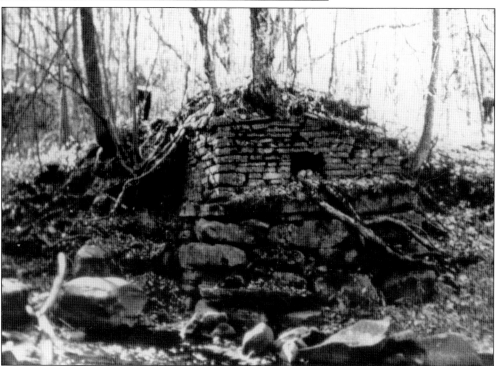

Tanneries provided many jobs for the early settlers of the area. Hemlock trees would be harvested for the tannins in their bark, which would be used to tan the hides and make leather. During the Civil War, leather was heavily used to make saddles and boots for the soldiers. Above are the remains of the Watson Hollow Tannery.

Conradt DuBois started the first tannery in the area at Tongore around 1800. In 1832, Daniel Case started a tannery in Shokan, and in 1850, Colonel Pratt and General Samson were running a tannery in what is now Samsonville. At its height in 1854, the tannery employed 70 men, and Samsonville became a hive of activity.

A large tannery was built by Nathan Watson in what is now Watson Hollow and was called the Metropolitan Tannery. The tannery employed many men, and they brought their families to live there. There was a school, a company store, and other commercial establishments. There remains today the foundation of a building where men would bring the water in from the Bushkill Creek and soak the hides before being tanned. Pictured is the Watson Hollow School in later years.

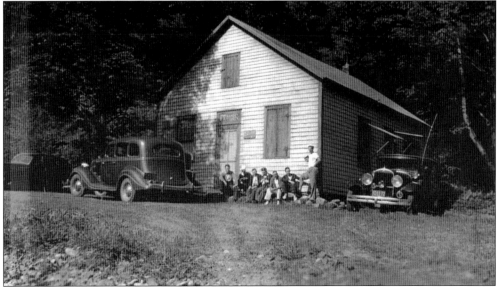

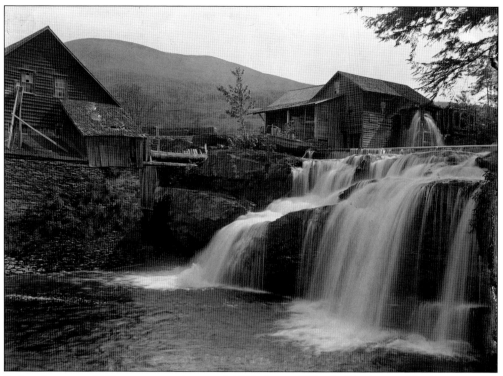

Before the town of Olive was created, around 1791, Lemuel Winchell had one of the first sawmills, gristmills, carding mills, and stores in the area. By the year 1870, there were 35 mills producing lumber, shingles, barrel heads, and barrel staves and four gristmills. Pictured is Shurter's sawmill in Samsonville, New York. (Courtesy of Raecine Shurter.)

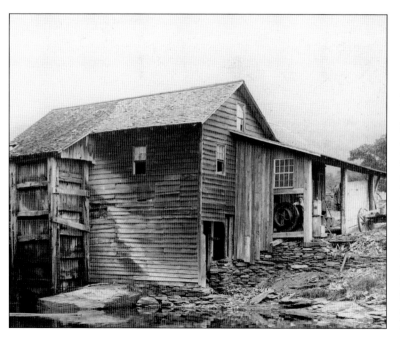

Another early mill was run by Asa Bishop and became a famous local landmark in the area. Bishop was married to Rebecca Winchell, and together, they ran a gristmill at Bishop's Falls and raised a family of 10 children. Seen here is Shurter's gristmill in Samsonville, New York.

One of Bishops' children, Jacob, became quite famous in the area. Jacob suffered from smallpox as a small boy and lost his sight. Although blind, he carried on in his father's footsteps as a miller, married Catherine Eckert, and had 12 children. It was said that he could tell the color of a horse just by touching it and never made a mistake with a customer's order. His sense of hearing was so strong that he could immediately tell if there was something wrong with the machinery of the mill. The mill was very productive because Jacob could work in the dark at night, and his sons would work during the day.

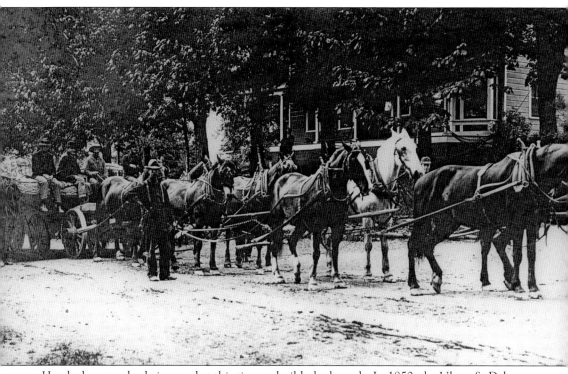

Hemlocks were also being used at this time to build plank roads. In 1850, the Ulster & Delaware Turnpike Company built a plank road from Kingston to Pine Hill. Unfortunately, under the weight of heavy wagons loaded with bluestone, the road did not last very long, and in 1862, a stone road was constructed. There were tollgates along the way; one was located at Olive Branch. It would cost someone 8¢ to go through the gate with a cart and a horse. A cart and two horses or a stagecoach would cost 16¢. J.B. Davis wrote in his diary in 1858 that it cost him $2.25 to travel by stagecoach from Delhi to Boiceville.

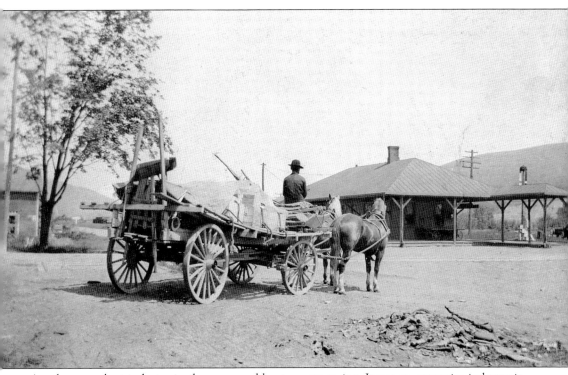

Another prevalent industry in the area was bluestone quarrying. It was an expansive industry in the 1800s, and a great deal of local bluestone was shipped to New York City. Bluestone does not get slippery when it becomes wet or crack in the winter, so it was ideal for building sidewalks and curbing. It would be hauled to Kingston to then be loaded onto ships heading for New York City.

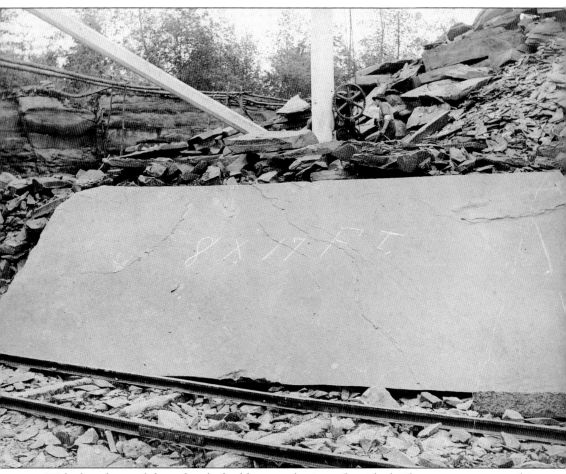
With the advent of the railroad, the bluestone business flourished. There was a stone yard in Broadhead Bridge and Boiceville. It could be a very dangerous occupation, with men often obtaining serious injury trying to harvest the stone. Many of the quarries that were widely used in its construction now lie under the Ashokan Reservoir. Seen here is bluestone from Ephram Bishop's quarry. (Courtesy of Kate McGloughlin.)

According to Vera Sickler in her book *History of the Town of Olive*, charcoal burning was another industry in the town of Olive during the 1800s. It would take five and a half cords of wood to make one ton of charcoal. The largest could be found at Maltby Hollow where Charles Maltby operated four kilns. The charcoal would then be hauled by wagon to the Shokan Station. It was a large enterprise with almost a hundred men employed.

The first tavern in the area was owned by Conrad Dubois and was located in Olive City in the late 1700s, just before the town of Olive was formed. Later, the first town board meeting in 1824 was held here, and at that time, it was run by Uriah Schutt. Seen here are the first meeting minutes from that meeting.

Another early tavern in the area was the Tongore Inn, built in 1774 by Peter Merrihew. It is now a private home in Olivebridge. The William Davis Tavern in Olivebridge was often used as a meeting place for local militia in the early 1800s. Pictured is the Winchell Inn, another early tavern.

Two

THE ULSTER & DELAWARE RAILROAD AND THE BOARDINGHOUSE INDUSTRY

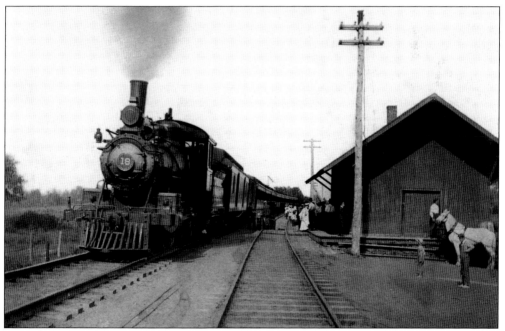

The Ulster & Delaware Railroad began as the Rondout & Oswego Railroad on April 3, 1866. Thomas B. Cornell of the Cornell Steamboat Company on the Rondout wanted to create a rail line to connect the rich resources of the Catskills to the already established Albany & Susquehanna Railroad.

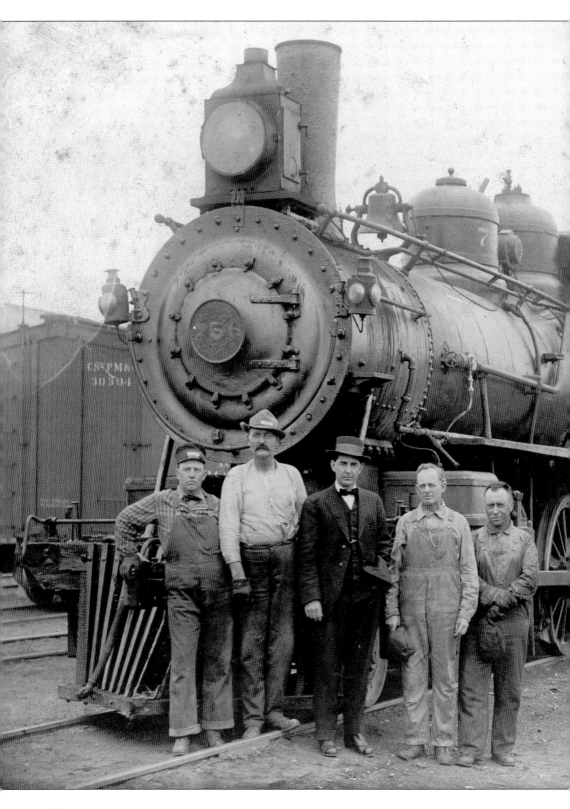

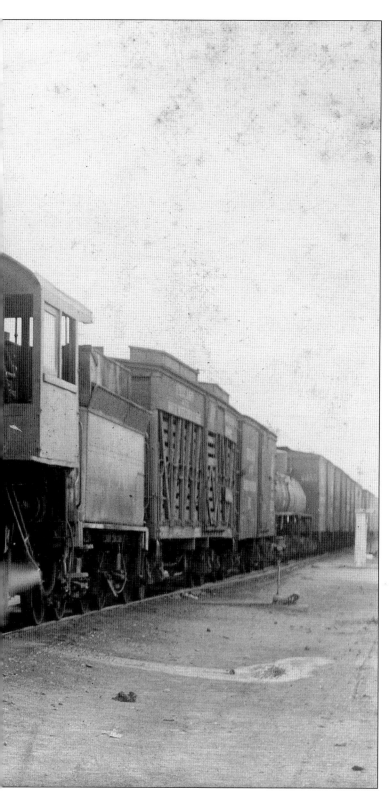

On September 20, 1870, Thomas B. Cornell reported that the railroad was up and running to Shandaken. One of the industries to benefit immediately from the new railway line was the bluestone industry. There were quarries at the bottom of High Point, Samsonville, Acorn Hill, and Krumville. Bluestone was shipped from the Rondout and down to New York City and other areas to build sidewalks and curbs and for other construction. Bluestone was also extensively used in the construction of the Ashokan Reservoir. Other freight items included coal, tanned hides, machinery, and produce from local farms.

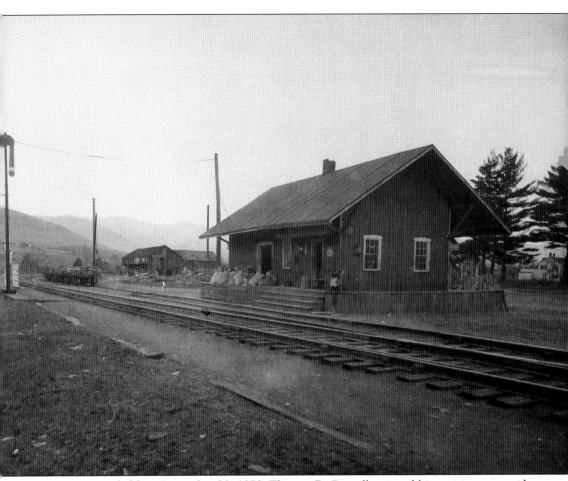

At a meeting held on September 20, 1870, Thomas B. Cornell resigned his position as president of the railroad due to conflicts with townships on the rail line. He would not rejoin until June 12, 1875, when the railroad—now called the New York, Kingston & Syracuse Railroad—went into bankruptcy. The railroad was reorganized and renamed the Ulster & Delaware Railroad, and Cornell again became president. Pictured is the original Shokan Station. (Courtesy of DEP Archives, Digital Image ID P001304.)

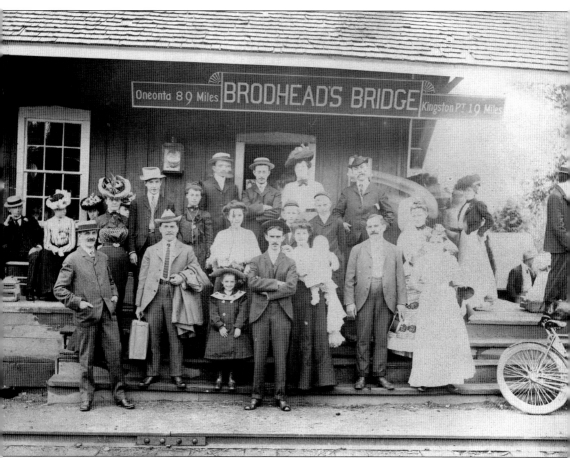

On May 25, 1870, the first passenger train ran from Rondout to Mount Pleasant and so began an industry that would allow the town of Olive to prosper. Vera Sickler, the town historian for many years, wrote, "The boarding house business became a money-making item when people still had to travel by stagecoach from the Hudson River boat landing into the mountains. The coming of the railroad brought the city dwellers into the mountains every summer, by the thousands."

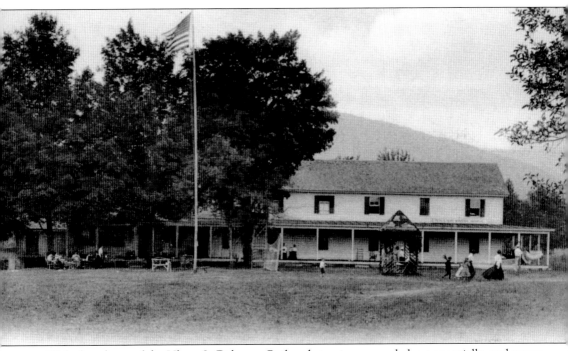

With the advent of the Ulster & Delaware Railroad, tourism expanded exponentially, and many families in the town of Olive took in boarders. There were some boardinghouses that were built in the area to accommodate 50–100 visitors. There were large hotels as well; the Willow House had rooms for 150 people.

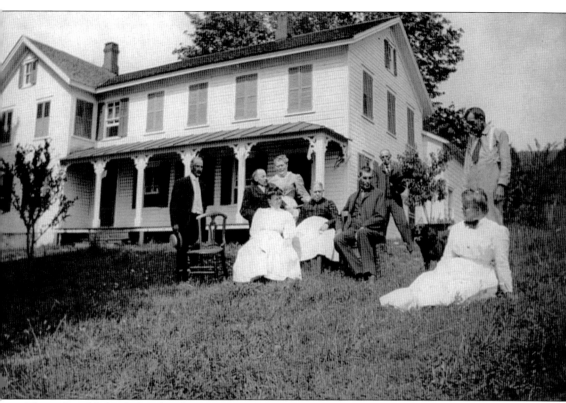

The railroad helped the already prosperous businesses in the town of Olive to thrive. Farmers were able to transport produce to the river ports along the Hudson River, and the "Milk Train" provided a means to transport over 30,000 tons of milk per year. Tourism expanded exponentially, and many families in the town of Olive took in boarders.

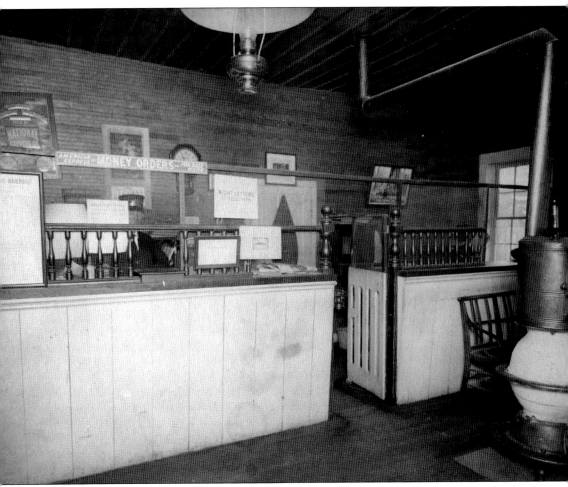

One of the many casualties of the construction of the Ashokan Reservoir was the boardinghouse industry. Eleven miles of the Ulster & Delaware Railroad had to be rerouted, and five stations were eliminated: Boiceville, Shokan, Brown's Station, Olive Branch, and Brodhead's Bridge. Broadhead Bridge and Brown's Station alone accounted for 712 available rooms in the area. These hamlets, along with their stations, would cease to exist with the arrival of the reservoir. Pictured here is the interior of the Broadhead Bridge station. (Courtesy of DEP Archives, Digital Image ID P001303.)

In 1911, work began on the new route for the Ulster & Delaware rail line that would circumvent the Ashokan Reservoir, and a new station would be constructed in the hamlet of Ashokan. During this time, the Ulster & Delaware Railroad filed a claim against the City of New York demanding $3 million in damages. They received $1.25 million from the City of New York, which also paid $1.5 million for the new rail line running along the reservoir. The first train traveled on the new tracks on June 8, 1913; in that same year, the railroad hit its peak of passengers at 676,000.

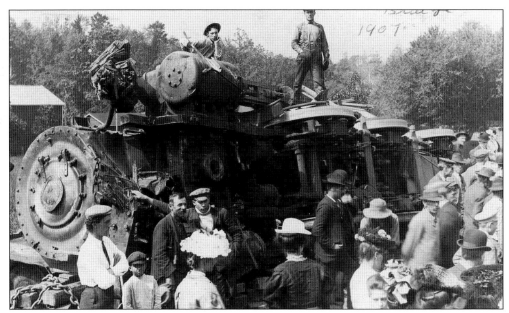

The Ulster & Delaware Railroad had its share of accidents, and several resulted in human casualties. The worst of these occurred in Roxbury on May 26, 1922, when a work train ran backward into a coal train, killing six people. On June 14, 1907, at Brodhead's Bridge, a coal train moving at excessive speed rear-ended a freight train; thankfully, there were no injuries.

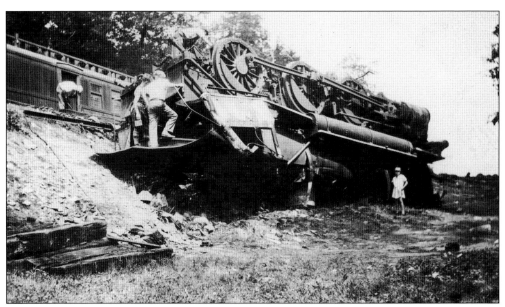

There were two casualties on August 23, 1930, near Ashokan when a boiler exploded in an engine, throwing it into a nearby ditch and killing both the engineer John Scully and fireman Lester Reed. The rest of the crew and 18 passengers were unharmed. Because their windows were closed in the railcar, the passengers could only hear a dull blast before the train came to a stop. (Courtesy of Kate McGloughlin.)

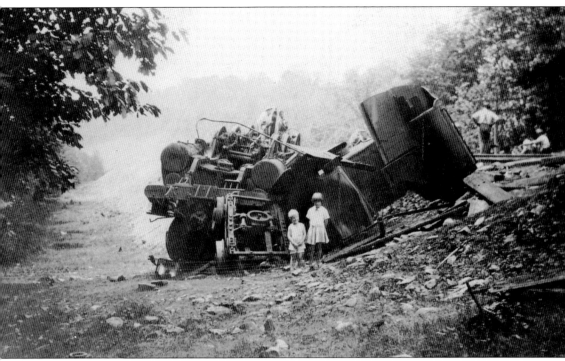

Three cars derailed, and the explosion ripped up to 150 feet of track. One of the cars that derailed belonged to the State Conservation Department and was named the Adirondack. It was carrying baby trout that were going to be used in the hatcheries in Phoenicia, Tannersville, and Haines Falls. It was determined that the explosion was due to a crown sheet failure. (Courtesy of Kate McGloughlin.)

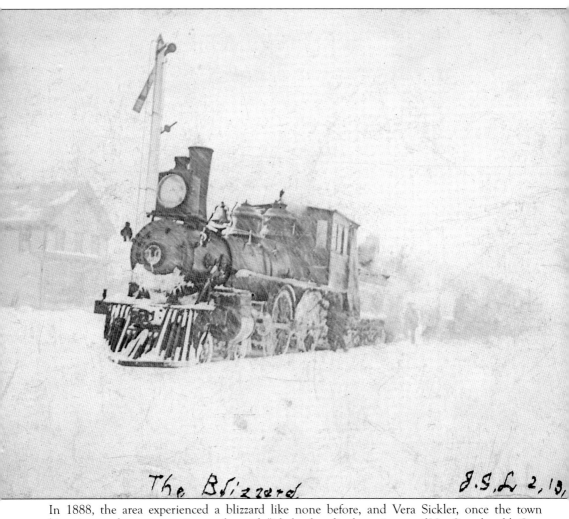

In 1888, the area experienced a blizzard like none before, and Vera Sickler, once the town historian, spoke to an eyewitness who said, "I helped to dig the train out of Van Steenbergh's Cut, in Brown's Station and after two days, we cut steps through 30 feet of snow to feed cattle in the barn." According to the National Weather Service, the blizzard lasted from March 11 to 14, 1888, and had a total accumulation of 46.7 inches of snow. In Olive Branch, two locomotives were sent out to help a stranded train but were themselves derailed on their way to help. The train had 15 passengers on board; it left Delaware County on Monday and did not make its way to Kingston until Friday.

ATTRACTION FOR SUNDAY SCHOOL
AND OTHER
EXCURSIONS.

CRISPELL'S GROVE.
AT WEST SHOKAN.

One of the most attractive spots in Ulster County for EXCURSION PAR-
IES and PICNICS. There is a pavilion capable of accommodating one
housand persons in case of storm. Not over five minutes' walk from
he U. & D. Railroad Station. All baggage and refreshments conveyed
) the Pavilion if required. Refreshments will be supplied to parties who
:sire.

M. H. CRISPELL,
WEST SHOKAN, ULSTER COUNTY.

Passengers on the Ulster & Delaware were not exclusively visitors from New York City. Local churches and Sunday school classes would take excursions into the mountains or to Crispell's Grove in West Shokan for picnics and outings. A local couple, Jennie Avery and Raymond Miller, took turns taking the train from West Shokan to Mount Tremper to spend a little time together and then head back home on the next train.

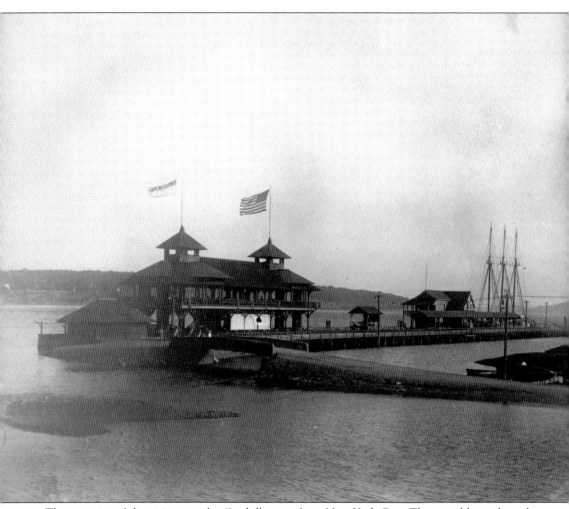

The majority of the visitors to the Catskills were from New York City. They would travel on the Hudson River Day line and arrive at Kingston Point landing or by the West Shore Railroad to the Kingston station. Once in Kingston, they would take the Ulster & Delaware Railroad to reach the western Catskills. If, by chance, they took the *Mary Powell* from the city, they would then need to stay at a hotel in either Rondout or Kingston and take the morning train to the Catskills, as it arrived at Kingston Point only in the evening.

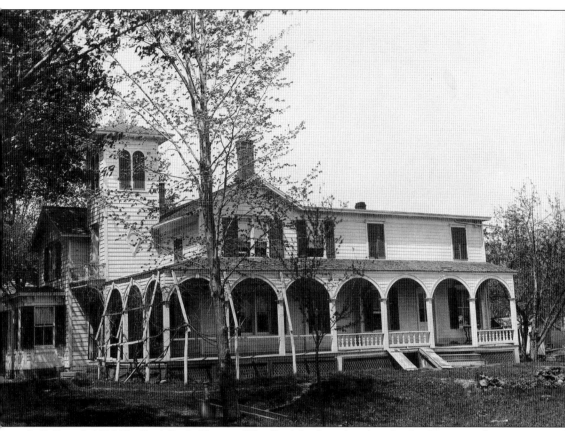

In R. Ferris's 1897 *The Catskills: An Illustrated Handbook*, he describes three levels of accommodations: farmhouses, larger boardinghouses, and hotels. The accommodations he mentions in his guide could be had for as low as $5 per week and up to $4 a day. Ferris explained that the farmhouse accommodations were a room on a working farm and offered good quality but simple fare. The boardinghouses catered to their visitors, but a higher rate should be expected. He described the hotels as "being equal to any in the world in comfort and elegant furnishings, and in the bill of fare." Pictured is the boardinghouse of Mrs. W.S. Boice of West Shokan. (Courtesy of DEP Archives, Digital Image ID P013231.)

The Browns' farmhouse was located on the banks of the Beaverkill at Brown's Station. The Browns' house had room for 25 and charged $6 a day. This home was destroyed to construct the Ashokan Reservoir. (Courtesy of DEP Archives, Digital Image ID P013788.)

The need for summer accommodations grew, and everyone who had a room to spare would rent it out. It is said that even henhouses were turned into rooms for boarders. (Courtesy of Kate McGloughlin.)

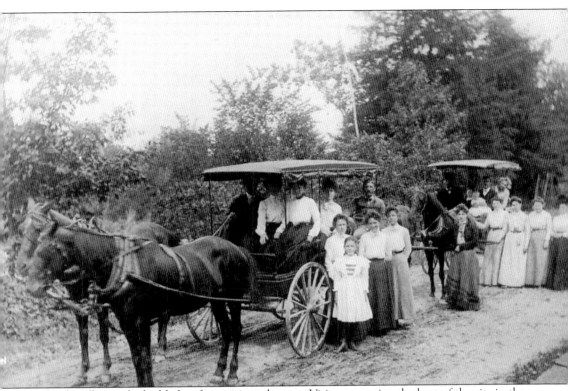

Bishop's Falls was the highlight of any visit to the area. Visitors escaping the heat of the city in the summer months would flock here to enjoy swimming holes and beautiful vistas. Located close by was the Bishop's Falls House, run by Frank and De Forest Bishop, which could accommodate up to 20 people.

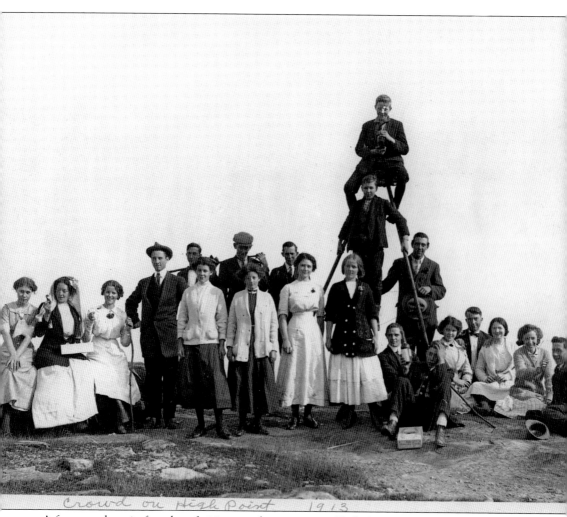

A frequent day trip for a lot of visitors to the area was to High Point Mountain near the Shokan station on the Ulster & Delaware line. The mountain covers 12 miles and is 3,098 feet above sea level, and the trail up to the summit was not very difficult for those who chose to make the ascent.

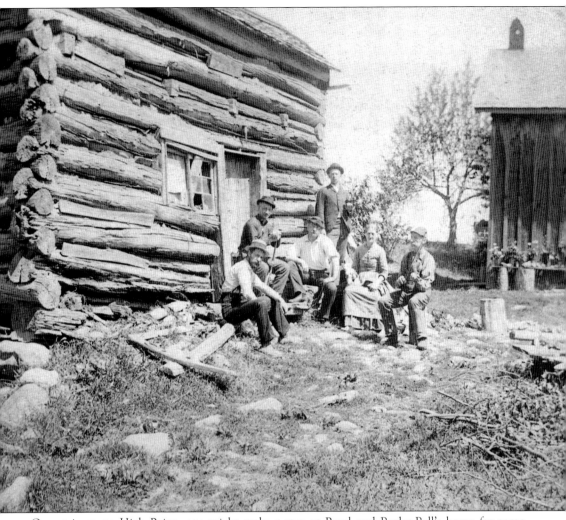

On a trip up to High Point, one might make a stop at Rowl and Becky Bell's home for some entertainment. Rowl liked to put on a good show and would play his fiddle and dance, while his wife's puppet danced along. Rowl was also known as a rattlesnake hunter, and he would milk the rattlesnake venom and use it to make a potion that he would sell to visitors.

Other interesting characters in the area were Enos Brown and his wife, who were bear hunters. The Browns initially moved to Traver Hollow in the mid-1800s to cook for the men who were working in the tanneries. They lived there until the tanneries eventually shut down. While Enos was known as a bear hunter, he also made a living leading hunting parties.

Eugene Kerr ran a boardinghouse in Watson Hollow and was also a noted bear hunter. It is said that he baited his traps with a sheep's head, and when the bear was caught, he would nail their hides and heads to the side of his barn. He too guided many hunting and fishing groups who came to the area to visit.

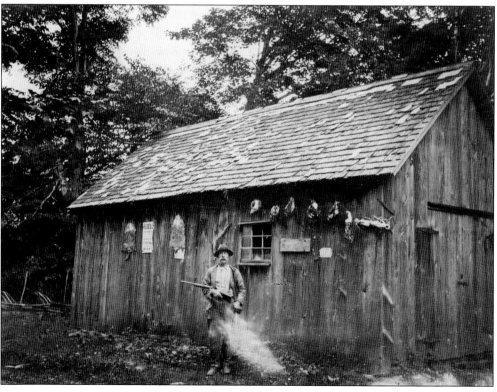

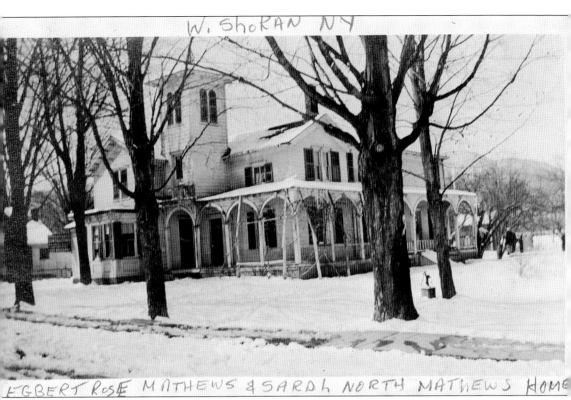

West Shokan was home to many visitors from the city due to its popularity as a fantastic trout fishing spot. The Mountain Gate House, owned by E.R. Matthews, accommodated 20 people. R. Ferris described the Mountain Gate House as being surrounded by fruit trees and having an abundance of fruit, vegetables, milk, butter, and eggs all produced on the property.

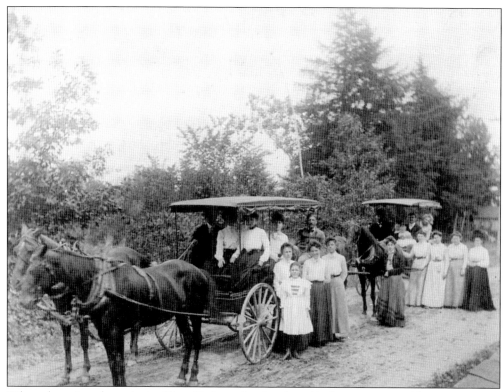

When departing the train in West Shokan, the first boardinghouse one would encounter was owned by Mrs. O.A. Phillips. Mrs. Philips had room for 12 boarders and was conveniently located next to the house of Dr. VanGaasbeek in case someone became ill.

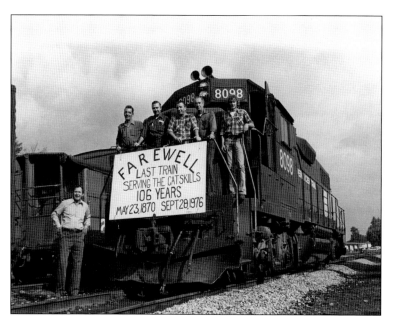

The Ulster & Delaware Railroad ceased to exist on February 1, 1932. The line then became the Catskill Mountain Branch, which was part of the New York Central Railway. Passenger service to the area ended in 1954, and the last freight train serving the Catskills rolled through on September 28, 1976. This ended 106 years of rail service to the area.

Three

ONE-ROOM SCHOOLHOUSES IN THE TOWN OF OLIVE

It is thought that the earliest school in the town of Olive may have been erected in the area in 1763, although at the time that area was still a part of the town of Marbletown. There may have been a few more at Bushkill and Tongore and on the Dickenerg (a high plateau of land between Brodhead and Shokan) that were constructed in the year 1800 or earlier. The schools were all made of timber. The first stone school was built on Shokan Road in 1817.

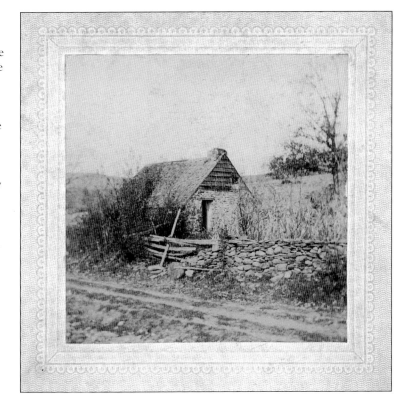

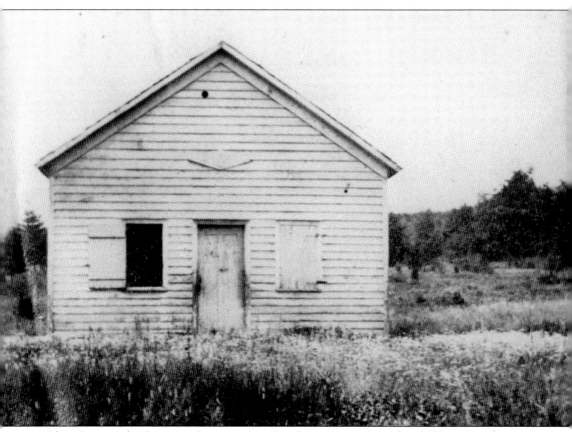

Olive City was the first seat of government after the town was formed in 1823, so it makes sense that the first school would be built in this area. The first school was said to be built of logs, but the exact date it was constructed is uncertain. Pictured is the Olive City school, which was later built around 1900.

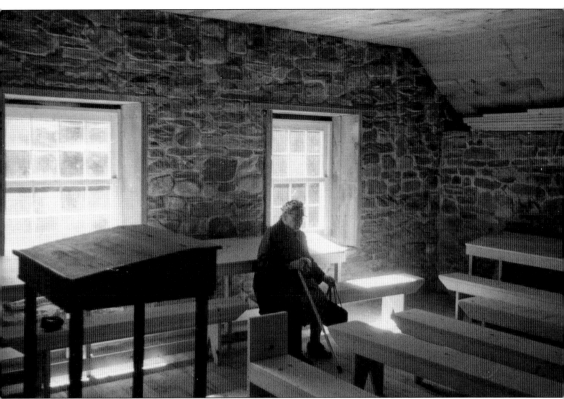

The 1817 stone schoolhouse was on the property of Vera Sickler, but there it lay in ruins. Andy Angstrom and the Ashokan Field Campus helped to relocate and rebuild it on their site off Beaverkill Road, now known as the Ashokan Center. Vera Sickler is pictured when the stone school had its dedication on October 26, 1985, at its new site.

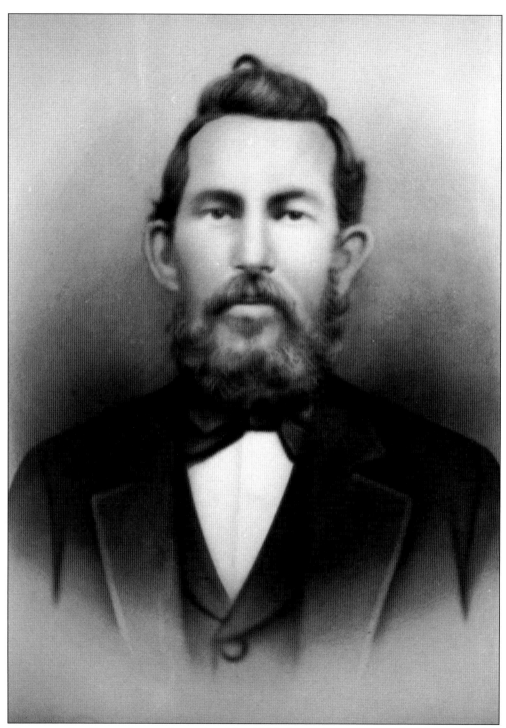

The stone schoolhouse that was located on Vera Sickler's property was active for 25 years. At that time, there were very few schools in the area, and children had to travel several miles to get an education. As the town grew, more districts were built so that students did not have to travel as far. In 1842, the schoolhouse was sold to John Dubois, Sickler's great-grandfather, for $12.

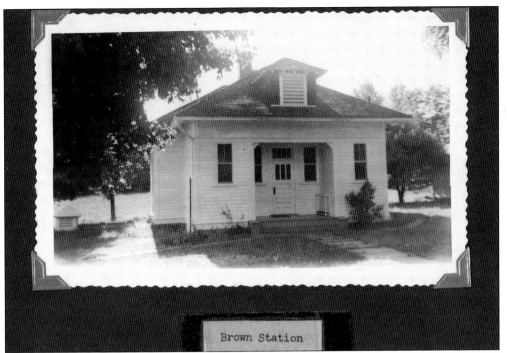

Brown Station

One-room schoolhouses provided education for students in the Olive area from 1817 until May 1952, when the schools consolidated and became Onteora Central School District. At its height in 1875, Olive had 15 district schools with 1,090 students attending. That is only 100 students less than what the Onteora Central School District has today. Pictured is the school that was located at Brown's Station, now under the Ashokan Reservoir.

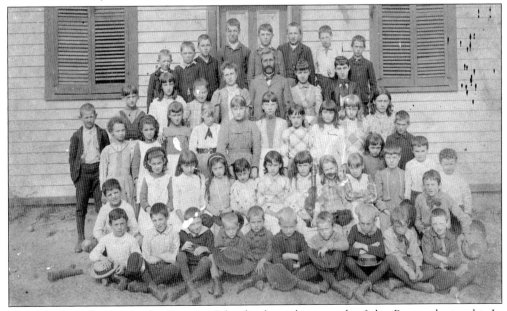

Among these schools was the Tongore School, where the naturalist John Burroughs taught. In April 1854, he accepted a position at the school and taught there until April 1856. It was while he was teaching at the Tongore School that he met Ursula North, who would later become his wife.

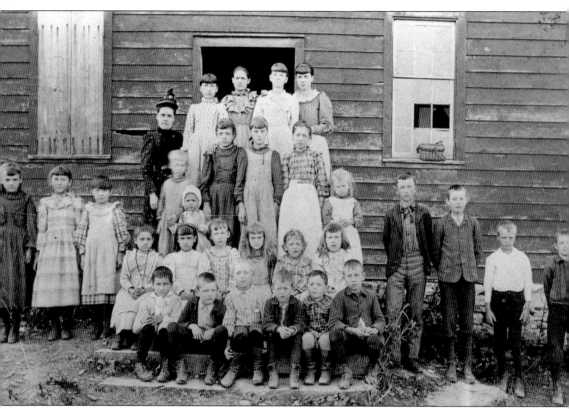

John Burroughs spoke of his time teaching at the Tongore School: "I began my school Monday morning April the 11th, 1854 and continued it for six months, teaching the common branches to twenty or thirty pupils from the age of six to twelve or thirteen. I can distinctly recall the faces of many of the boys and girls to this day. Two or three of the boys became soldiers in the Civil War and fell in the battle of Gettysburg."

At that time, teachers would pay for lodging or families would take turns hosting them. John Burroughs recalled, "I boarded round, going home with the children as they invited me. I was always put in the spare room, and usually treated to warm biscuits and pie for supper. A few families were very poor, and there I was lucky to get bread and potatoes."

Brodhead was located between Olive City and West Shokan; pictured is the Brodhead School. Brodhead received its name from the Brodhead family, who settled in the area before 1800. Conrad Brodhead was present at the first town meeting in 1824 and was elected inspector of schools.

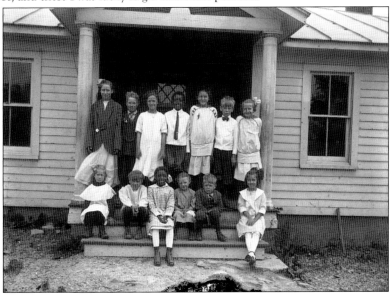

TEACHER'S CONTRACT

SECTIONS 561 TO 566 INCLUSIVE OF THE EDUCATION LAW OF 1910

I, Daisie B. Winchell of Olive Bridge county of Ulster a duly qualified teacher, hereby contract with the board of trustees of district no. 12 town of Olive county of Ulster to teach the public school of said district for the term of 3 & consecutive weeks, except as hereafter provided, commencing Sept 4 1922 at a weekly compensation of 22 dollars and 23 cents payable at the end of each thirty days during the term of such employment. Four per cent of the amount of each order or warrant issued in payment of the compensation required to be paid hereunder shall be deducted as provided by article 43 B of the Education Law relative to the State Teachers Retirement Fund.

And the board of trustees of said district hereby contract to employ said teacher for said period at the said rate of compensation, payable at the times herein stated.

Said board of trustees reserve the right to provide for a vacation or vacations of not more than _____ weeks in the aggregate, during said term, which vacation shall not count as a part of the term of service above referred to.

Dated May 15 1922

Daisie B. Winchell — Teacher

Horace Myers — Trustees

This contract shall be executed in duplicate and one copy thereof given to the teacher and one retained by the board.

In 1830, a teacher in the town of Olive received $8 per month. In 1900, this amount rose to $120 per month. In the early 1800s, the only preparation a teacher needed before they stepped into their classroom was a six-to-eight-week course. These teachers taught students from grade first through eight in the subjects of reading, math, writing, history, music, and geography.

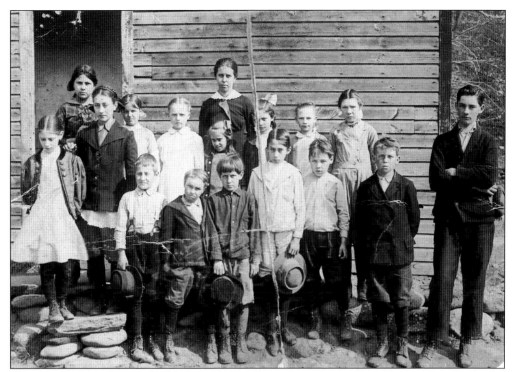

The interiors of these one-room schools have been described by many local residents as being sparse. There was a wood-burning stove for heat, nails for students to hang their coats, a water pail with a tin dipper for drinking water, hard benches to sit on, and a large pile of wood to fuel the stove. Later, some of the schools did add electricity but continued to have outhouses. Pictured is beloved teacher Hazel Bell and her students at Brown's Station.

Local landowners were very generous and often donated a piece of their property for a school or a church to be constructed. This is a notice put out by the trustees of the No. 8 school, which was the West Shokan School. In later years, the West Shokan School became the first Olive Free Library.

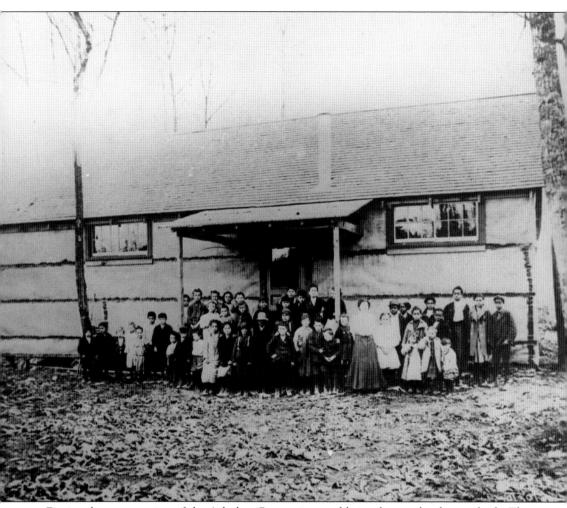
During the construction of the Ashokan Reservoir, an additional two schools were built. These schools were not only used to educate the children of the workers who had come to build the reservoir, but also to teach English to the many adult immigrants who were newly arrived from Europe.

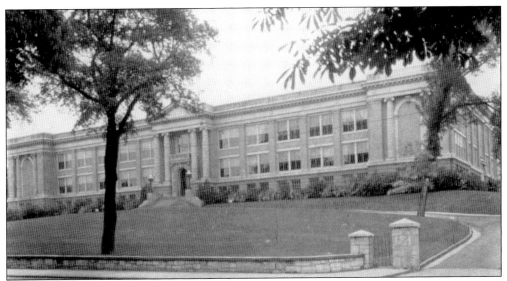

In the town of Olive, if a student wanted to continue their education past the eighth grade, they had to enroll at Kingston High School. Kingston High School opened its doors in 1915, and many students from Olive attended there before the Onteora high school was opened in 1952. If a student had relatives or family friends in Kingston, they could stay there during the week and go home on the weekend.

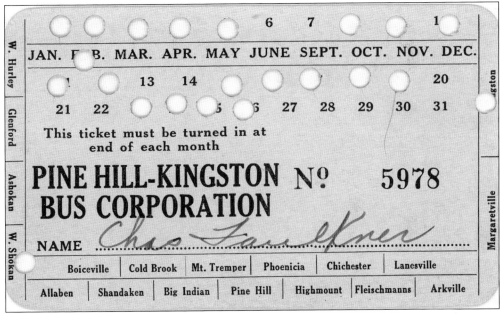

In later years, students could take the Pine Hill bus, leaving West Shokan at 7:35 a.m. and arriving at Kingston High School at 8:40 a.m. and then leaving Kingston High School in the afternoon at 3:45 p.m. and arriving back in West Shokan at 4:45 p.m. In 1931, the trustees of the schools in the town of Olive were paying the Pine Hill Bus Company $3.75 per pupil per week for transportation.

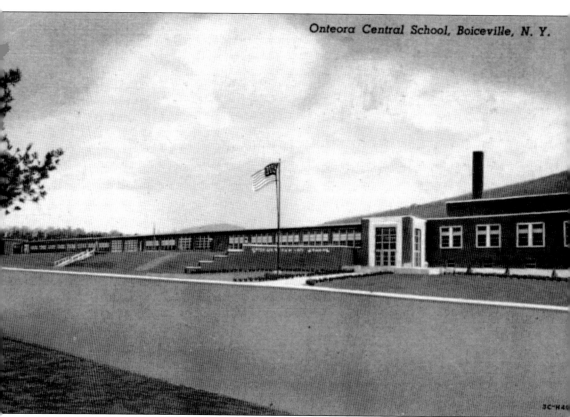

Onteora Central School, Boiceville, N. Y.

The time for consolidating one-room schools in New York State had arrived, and in 1948, it was decided to create the Onteora Central School District. Onteora opened its doors for the first time in September 1952. It is said that it was the first one-story school in the state. The district opened with 820 students who were bused across 350 miles. The name "Onteora" comes from the Native American word for the Catskill Mountains.

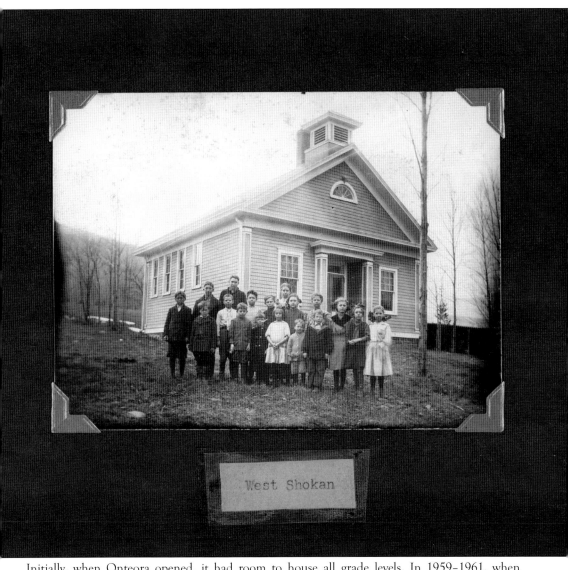

Initially, when Onteora opened, it had room to house all grade levels. In 1959–1961, when Onteora was becoming too crowded, West Shokan School was used to teach kindergarten. In 1960, the Reginald R. Bennett Elementary School was opened to provide additional room for 368 students, but the kindergartners were not moved in until 1961.

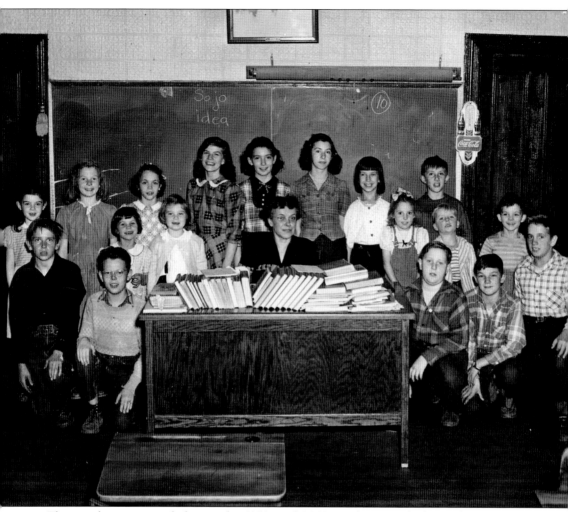

The population was exploding in the 1950s and 1960s, and even with the newly built Bennett Elementary School there still was not enough room. So it was necessary to build the Phoenicia Elementary School, which opened in 1965. During this time, split school sessions were run due to a lack of space.

Four

NEW YORK CITY NEEDS WATER

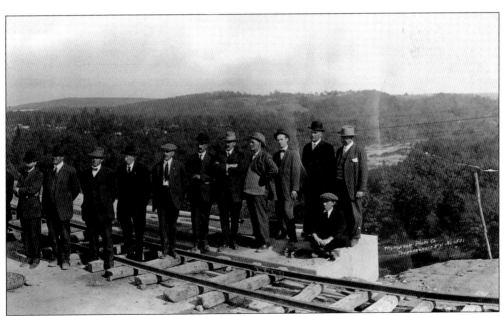

New York City thought its worries about water were over when the Croton Aqueduct was finished in 1890, but the city was growing at a rapid rate. Immigrants were arriving in record numbers, and there were no regulations in place to manage wasted water or the rationing of it.

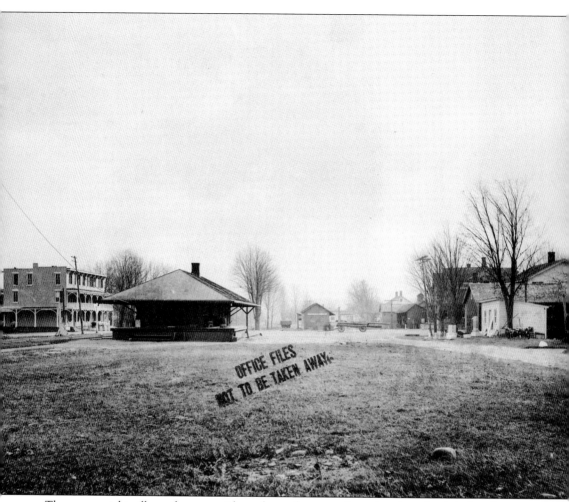

There were eight villages that were either relocated or ceased to exist when the Ashokan Reservoir was constructed. Olive City, Brodhead's Bridge, and Ashton lie under the reservoir, never to exist again. The villages of West Shokan, Shokan, Glenford, Boiceville, and West Hurley would be relocated but completely altered. This is a photograph of Old Shokan. (Courtesy of DEP Archives, Digital Image ID p042310.)

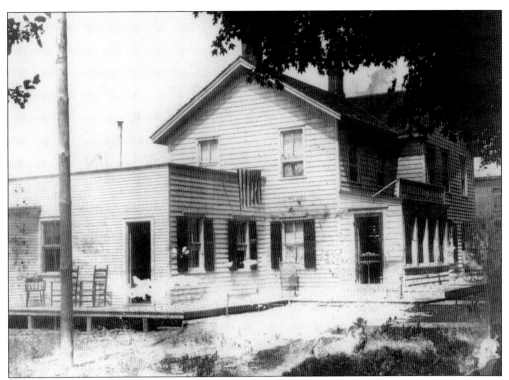

Brodhead's Bridge, named for the Brodhead family, was one of the hamlets that was leveled when the reservoir was built. Located there was the first railroad station built for the Ulster & Delaware Railroad. Property in this area had been in the Brodhead family for over 200 years. Seen here is the Brodhead Store.

Farming was the main occupation of the inhabitants of the Esopus Valley. The soil there was rich and fertile and yielded an abundant amount of crops. This prolific acreage would soon be covered by water and the self-sufficient families who farmed them would be left without a home or occupation. (Courtesy of Kate McGloughlin.)

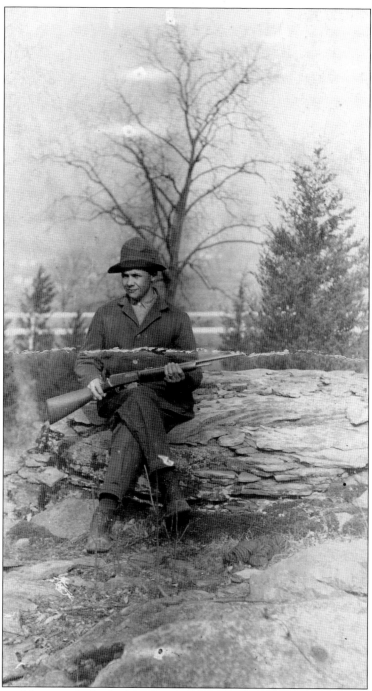

Some families, if they were lucky, had land on both sides of the "take line" and could relocate up the hill from their flooded lands. Elwyn Davis, a longtime resident and chronicler of the times, rebuilt his home above the place where his family had lived for generations. Instead of the rich soil he was used to, he had to try and farm the rocky soil on the hills surrounding it. Many of the residents who were able to make their livelihood farming were no longer able to do so and took jobs working on the very reservoir that had taken their homes.

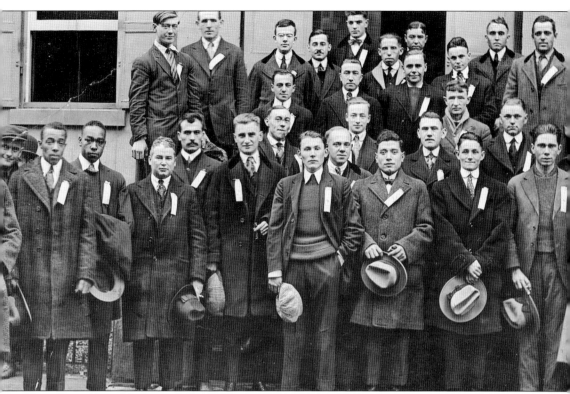

Surveyors were sent to assess the feasibility of constructing a reservoir in the area. Often, they would trespass on private property, not worrying about asking for permission from the "ignorant folk" of the area. These surveyors were searching for three requirements needed to bring water to New York City. In Hamlin Abbott's book *A Subway for Water*, he explains that the water had to be located where it could be easily transported by pumping or gravity, abundant, and pure.

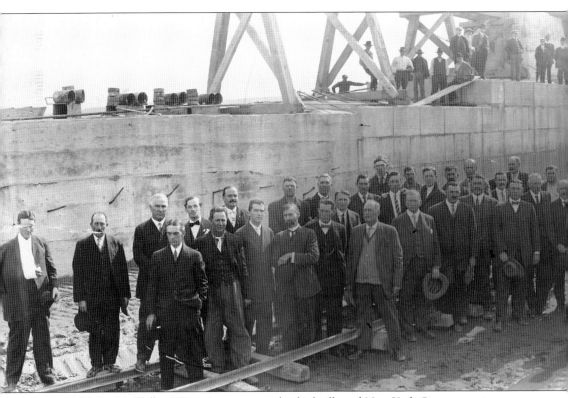

In 1905, the McClellan Water Act was passed, which allowed New York City to acquire property through eminent domain and develop reservoirs in the Catskills. This was the time when the New York City Board of Water Supply was created, which became responsible for the supply of water from upstate to New York City.

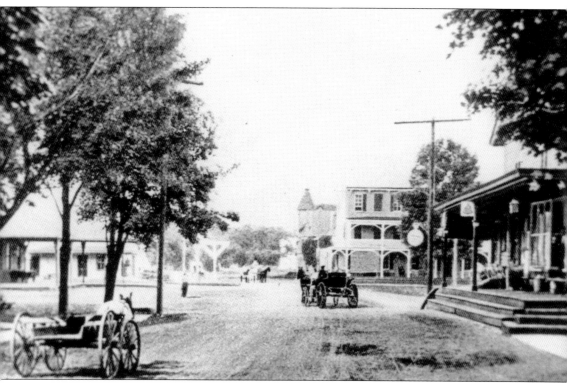

In *Water For a City*, Charles Wiedner describes some of the losses incurred in the area: 504 dwellings; three times that number of barns, shops, and outbuildings; 9 blacksmith shops; 35 stores; 10 churches; 10 schools; a gristmill; 7 sawmills; general stores; and meat markets. In the future, some of these structures were rebuilt, and although the inhabitants were resilient, the area never fully recovered from what had been lost.

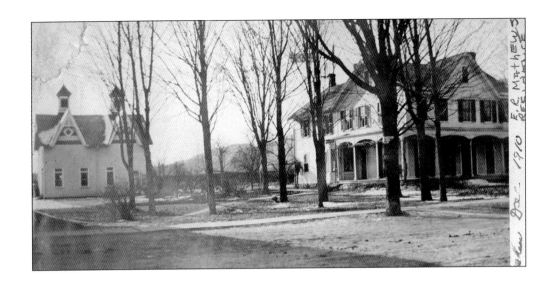

Delancy Matthews built up a business he had inherited from his father, Egbert Matthews. Egbert and James North began the business in 1879. At its height, just before the construction of the reservoir, the annual net profits of the Matthews and North business enterprise was approximately $80,000. They owned a general store and post office, and they sold horses. It was in this store that the first telephone office in the area was located. When the reservoir was approved for construction, Delancy Matthews appealed to the courts but without success. He closed his business in June 1913 and moved to nearby Kingston. He sold what was left to William Colonge, who operated a store in West Shokan after the reservoir was built. Pictured is the home of Delancey Matthews.

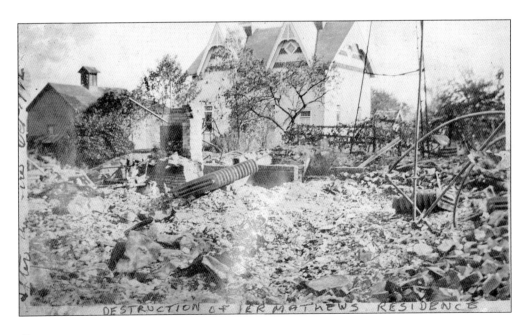

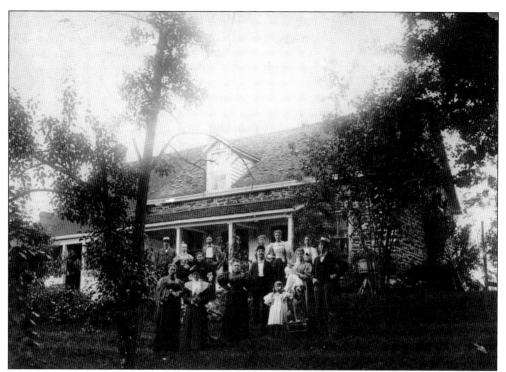

Frank and Deforest Bishop ran a profitable boarding business, but it did not save them from being the first people to have their house torn down to create the dam for the Ashokan Reservoir. It took them four years in court to settle their claim against the City of New York.

The Bishop Falls House was torn down on May 5, 1908. It had been a popular boardinghouse for a great many visitors from New York City. In fact, many of the employees of the contractors of the Ashokan project enjoyed staying there at the start of construction when accommodations were few and far between. It is said that Frank and Deforest Bishop had just added 10 rooms to the house before it was torn down.

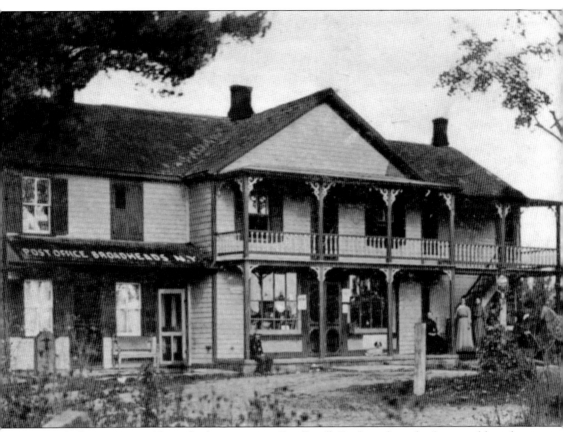

In the late 1800s, Ira Elmendorf ran a store in Brodhead's Bridge, where the first switchboard was installed. The store was torn down for the construction of the Ashokan Reservoir and taken to the town of Ashokan, where it became the Alonzo Haver Garage.

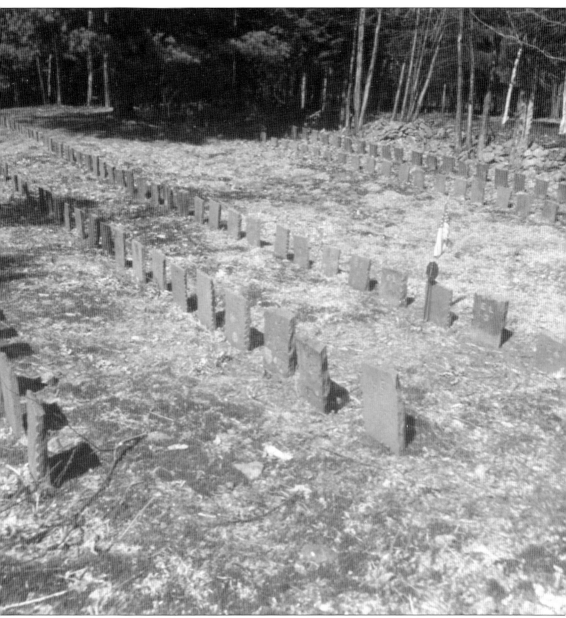

In Bob Stueding's *Last of the Handmade Dams*, he writes, "In total some 2,720 bodies were removed from the floor of the reservoir. Of these bodies, most were identified. However, some 368 remained either unknown or unclaimed. By Agreement 81, in 1911, these bodies were removed from reservoir property by Mathias and Alonzo Burgher and Joseph Hill. The bodies were reinterred in the Burgher Cemetery at the head of Watson Hollow in the new West Shokan. A bluestone marker 12 inches high by 12 inches wide was inscribed with two letters indicating the name of the previous cemetery, and a serial number for identification was set at the head of each grave. For many years afterward, some of these cut stones, which had not been used, remained in the area, leaning against trees or lying unused in fields. To this day, however, over 100 bodies, which were recorded in files as having been buried in particular cemeteries, remain unlocated, and thus now rest somewhere beneath the liquid grasp of Ashokan's waters."

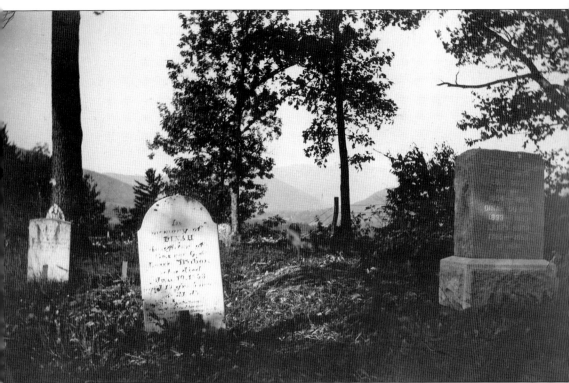

April Beisaw, an anthropologist who has done extensive research in the area, found that the Lee Cemetery contained 549 graves before the Ashokan Reservoir came to Olive. Buried there were members of the Lee family (George, Wallace, Priscilla, Sarah J. Edward, Carrie, Nelson, Munroe, Ann York, and Kate) among members of almost every other Olive family. Nathaniel K. Van Gaasbeek, captain of the steamboat *Isaac N. North*, is likely among those buried there. He was listed on the Lee burial removals, along with Miron Van Gaasbeek, yet neither appear in any public grave records as being buried somewhere else. Pictured is the Sand Hill Cemetery, one of the cemeteries that was removed. (Courtesy of Janette Guiliano Kahil.)

CEMETERIES

THE BOARD OF WATER SUPPLY OF THE CITY OF NEW YORK ON MARCH 30, 1909, ADOPTED THE FOLLOWING RESOLUTIONS:

RESOLVED, That the removal of bodies and tombstones from all cemeteries and lands acquired for the Ashokan Reservoir under Chapter 724 of the Laws of 1905, as amended, should now be proceeded with, and that the sum of $15.00 be allowed and paid to the friend or relative of any deceased person under whose supervision a body is removed, after such removal is made and the former grave refilled, and that the sum of $3.00 additional be paid for the expense of removal and resetting of the ordinary head and foot-stones, and that the removal of other stones, railings, fences, etc., be made a matter of agreement upon written application to the Chief Engineer; and, further, be it

RESOLVED, That written notice of any and all intended removals must be given to the Chief Engineer or his properly accredited representative, and that a proper voucher for the work of removal must be presented after said removal; and, further, be it

RESOLVED, That all bodies not removed before November 1, 1910, are to be removed by the Board of Water Supply to such cemetery as the Board may select, unless before that date some cemetery within a distance of ten miles from the present place of interment is designated by the relative or friend for the re-interment, and notice thereof filed with the Chief Engineer; and, further, be it

RESOLVED, That these resolutions be made public by advertising in the towns and places affected.

Written applications under these resolutions should be filed without delay with **Carleton E. Davis, Department Engineer, Brown's Station, New York,** or with **Frederick K. Betts, Division Engineer, 293 Wall Street, Kingston, New York.** Forms of application and any information will be furnished on request.

Burials have been made on the following parcels as numbered on the Board of Water Supply — Ashokan Reservoir maps filed in the County Clerk's Office at Kingston, New York.

PARCEL	NAME	POST OFFICE	PARCEL	NAME	POST OFFICE
1-B	Hollister	Olive Bridge	392	Evergreen	Brodhead
36	Winchell	Brown's Station	394	Rider	Brodhead
47	Knoey	Brown's Station	448	Wank	West Shokan
175-A			483	Davis	Boiceville
175-B	Olive Bridge	Brodhead	491	Krom	Boiceville and Shokan
175-C			526	Pine Grove	Shokan
183	Elmendorf	Brown's Station	539	Reformed Church	Shokan
186	Brooks	Brown's Station	627	H. Boice	Ashton
227	Hogan	Ashton	659	Lee	Glenford
237	Hales	Ashton	680	Green	Brown's Station
239	Jones	Ashton	699	Delamater	Olive
251	Mulligan	Ashton	700	V. Davis	Olive
271-B	Cudney	Brown's Station	711	Delamater	Olive
289	Terwilliger	Ashton	736	Wolven	West Hurley
382-A	Bloom	Brodhead	772	Sparling	West Hurley
382-B	Brodhead	Brodhead	748	Holmes	West Hurley
388-A	Boice	Brodhead	761	Rowe	West Hurley
388-B	Gulnac	Brodhead	762	Eckert	West Hurley
389	Ennist	Brodhead	788	Ostrander	West Hurley

Copies of said maps can be seen at the offices of the engineers above named.

Dated, 299 Broadway, New York, April 15, 1909.

JOHN A. BENSEL
CHARLES N. CHADWICK
CHARLES A. SHAW

Commissioners of the Board of Water Supply of The City of New York.

A friend or relative received $15 for the removal of each body and $3 for removing and resetting a headstone. The Merrihew family donated land next to their property to create the Tongore Cemetery to provide a home for some of the bodies that were removed. In general, many of the disinterred family members stayed in surrounding cemeteries, but some were moved down to Kingston.

Florence Eckert Guiliano tells a story about an older couple who did not want their house taken for the reservoir. The wife and husband took turns going into the well on their property, so they could not be forced out. They eventually were removed, but it enabled them to stay on their property for a few extra months. Seen here is the John Dubois family, whose home is now under the Ashokan Reservoir.

Local residents tried to fight back by bringing court cases against New York City for loss of wages and what they felt were low assessments of their property. The New York City Board of Water Supply estimated the value of the reservoir property at $331 per acre, but due to legal loopholes, they were able to purchase many of the parcels for just $250. Pictured here is the store owned by Delancey Matthews.

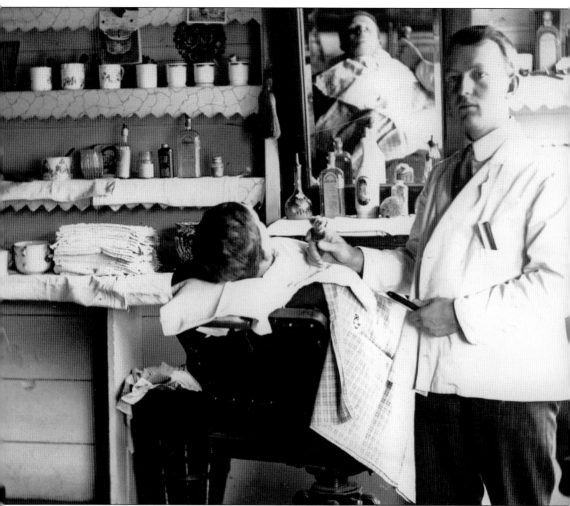

Businesses put claims in for the loss of their livelihood, but what was settled on was usually only a small fraction of what was asked. Most of the awards were only 20 to 25 percent of what was proposed. William Green, a barber and owner of a sporting goods store, only received $500.

Ephram Bishop owned a bluestone quarry that provided the bluestone for the sidewalks on Broadway in Kingston as well as some sidewalks in New York City. This picture was used as evidence in his court case against the New York City Board of Water Supply. (Courtesy of Kate McGloughlin.)

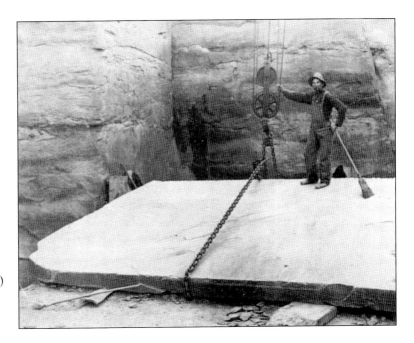

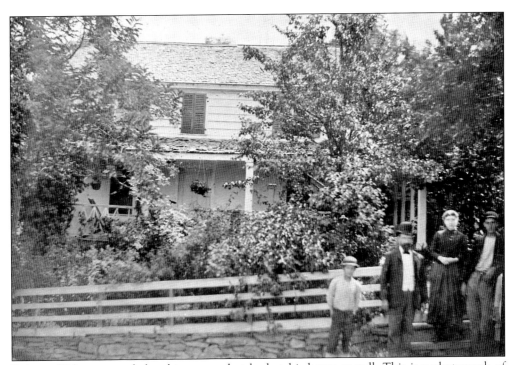

Ephram Bishop not only lost his quarry, but he lost his home as well. This is a photograph of Ephram and Anna Bishop at the front gate of their home in Olive City before it was destroyed. (Courtesy of Kate McGloughlin.)

VAN STEENBERGH HOME AT OLD BROWN STATION

Unfortunately, moving the train line meant that three more farms would be destroyed. The Elmendorf, Green, and Van Steenbergh farms would be taken in order to relocate the railroad. Vera Van Steenbergh, in her book *Town of Olive Through the Years Part One*, remembers her ancestral home being lost. When still residing in her home, she could hear the hammering of the nails going into the rails for the new line. Her family lost 80 acres as well as a newly planted orchard.

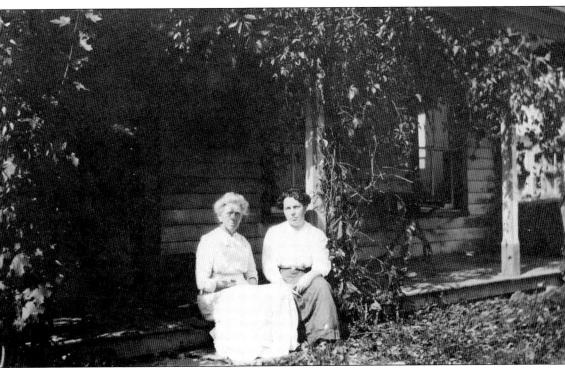

The Ashokan Reservoir construction began in 1908 and was completed in 1915. It is said that 2,300 people were relocated, thousands of buildings moved or demolished, and 2,720 graves were transferred to other cemeteries. Seen here is the Van Steenbergh family in a photograph taken on the last day in their home.

Pictured is old Shokan before the reservoir was built. Shokan was one of the towns whose boundaries allowed it to be relocated. It was a favorite location for summer boarders and had a bustling community. There were doctors' offices, a dentist, a tannery, a general store, a post office, two churches, and a railroad station. (Courtesy of DEP Archives, Digital Image ID p001217.)

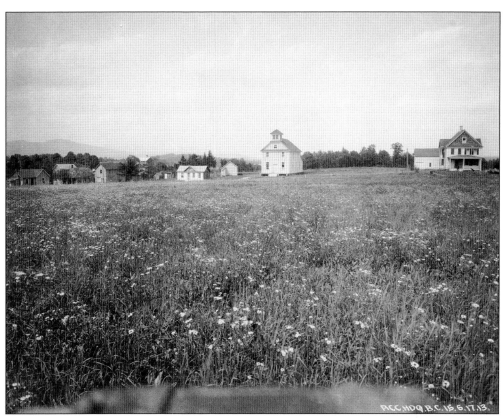

In R. Ferris's *The Catskills: An Illustrated Handbook*, he describes Brown's Station as "full of wildflowers with a fine rolling plateau." Brown's Station changed drastically from the onslaught of New York City Board of Water Supply workers and essentially became a construction camp. After the reservoir was completed, there was no longer a use for Brown's Station, and the entire area was burned. (Courtesy of DEP Archives, Digital Image ID p010879-1.)

Pictured here is the Elliot family standing in front of their beautiful stone home. This was just one of many homes at Brown's Station to be destroyed. (Courtesy of Kate McGloughlin.)

81

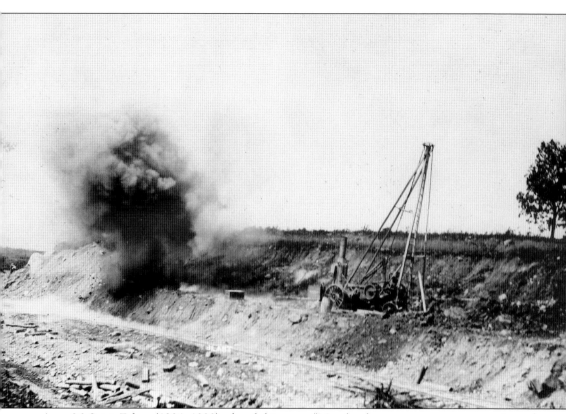
Anne McSpirit Eckert (1904–1993) relayed this story: "My school was two rooms, one upstairs and one down. We had two teachers, and of course the little children were downstairs. I was downstairs, the ones in the upper grades were up. And one day the NYC contractors were removing tree stumps by blowing them up with dynamite. While we were in class, a stump flew up in the air and came down on the roof of the school! After that happened, we were all downstairs."

Many homes within the "take line" were either moved by their owners or purchased by someone else and dismantled and relocated. One such building was a gift shop called the Nest Egg in Phoenicia, which also used to be the Matthews and North General Store in West Shokan.

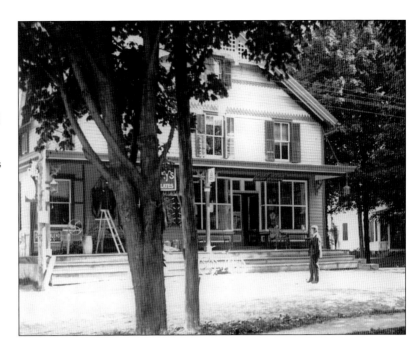

Vera Sickler writes in her book the *History of the Town of Olive* that after losing their homes and businesses, Jacob Crispell and Abner Winne decided to purchase 60 areas in Ashokan and create a new community for people to live in. These lots were laid out facing the new road, and some of the houses were moved up from the "take line." (Courtesy of the New York State Department of Environmental Protection.)

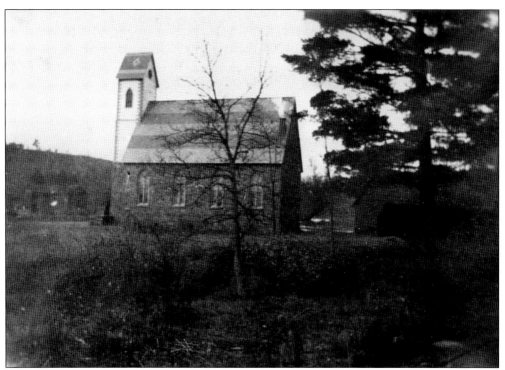
Stewartville was located below the main dam of the Ashokan Reservoir. During the construction of the reservoir, this church was used to house mules.

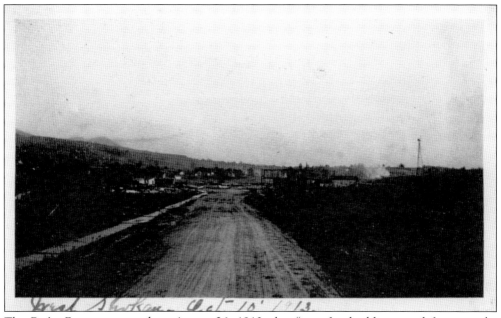
The *Dailey Freeman* reported on August 26, 1913, that "very few buildings are left now to be burned. The trees are all cut down and the village is fading as a dream. It's a sad regret to many, for the associations centered there were dear and will not easily be forgotten."

Five

Building the Ashokan Reservoir

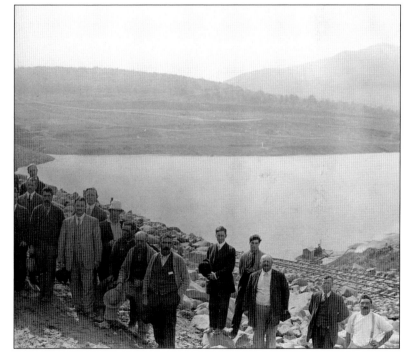

The Ashokan Reservoir, when filled, has a capacity of 122.9 billion gallons of water and 40 miles of shoreline. There are 5.5 miles of dams and dikes. The reservoir supplies 40 percent of New York City's drinking water.

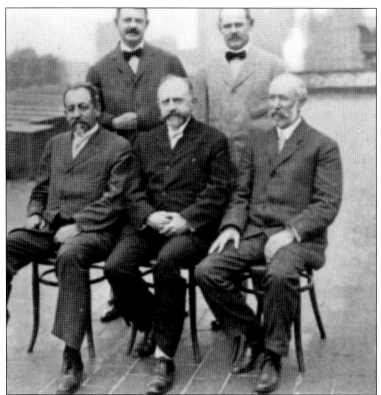

J. Waldo Smith was named chief engineer for the Ashokan Reservoir project. He was born in Lincoln, Massachusetts, and graduated from the Massachusetts Institute of Technology. He served with the New York City Board of Water Supply as chief engineer from 1905 to 1922. While the reservoir was being built, he lived in Shokan, just outside the reservoir basin. Smith is pictured standing on the right.

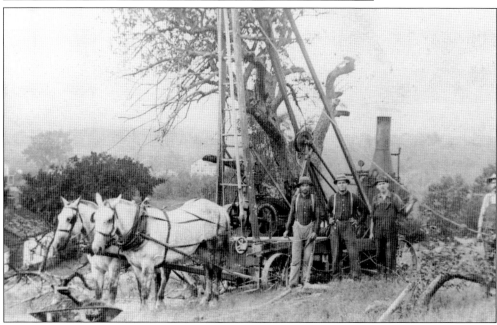

In 1906, the headquarters was erected at Brown's Station, and surveyors began taking soil samples and core borings to find the best location for the dam. Initially, it was thought that West Hurley would be the location for the dam site, but from the topographical studies completed, it became clear that Olivebridge was a more favorable location.

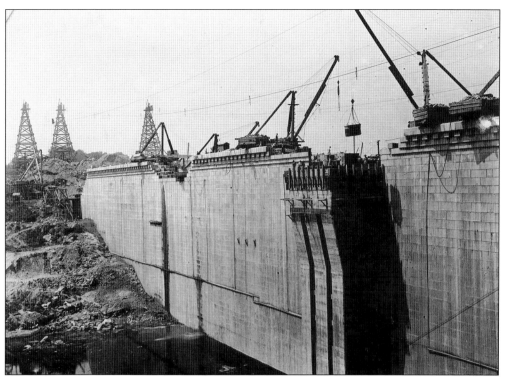

The length of the Olivebridge Dam is 4,650 feet long and 210 feet high. To hoist the stone and concrete needed to create the dam, 16 wooden derricks were put in place. Each derrick could carry 10 tons of material.

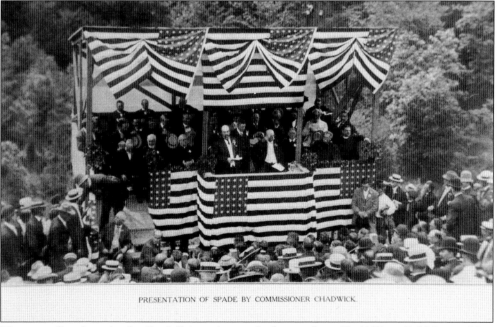

PRESENTATION OF SPADE BY COMMISSIONER CHADWICK

The groundbreaking for the Catskill Aqueduct took place on June 20, 1907, in Cold Spring, New York. About 1,000 people attended, and Mayor McClellan was there to give a speech.

Construction of the Ashokan Reservoir began on September 5, 1907. MacArthur-Winston was awarded the construction contract of $12.6 million. In 1911, the company employed up to 17,243 workers for the project.

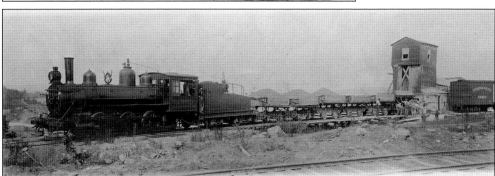

In *Liquid Assets: A History of New York City's Water System*, Diane Galusha writes, "MacArthur and Winston quickly opened a bluestone quarry and built another rail line, including an 89-foot-high, 390-foot-long steel trestle over the Esopus to get to it. They erected a machine shop for the repair of locomotives, steam shovels, traction engines and steamrollers; established labor camps; and put up cement storage buildings, stone crushing plants, power houses, and other buildings."

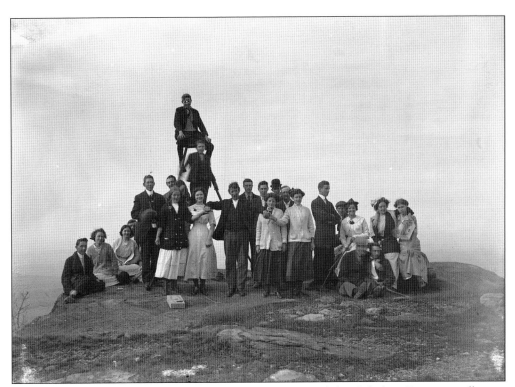

Triangulation towers were used during the construction of the Ashokan Reservoir, allowing surveyors to take thousands of accurate measurements. Pictured is a triangulation tower located at High Point.

The stone tower that is now the J. Waldo Smith monument was initially used as a triangulation tower and was called the McClellan Triangulation Monument. Kate McGloughlin, a local resident and artist, shared that her great-grandfather Spencer Levi Jones worked on the carving and building of this monument. (Courtesy of Kate McGloughlin.)

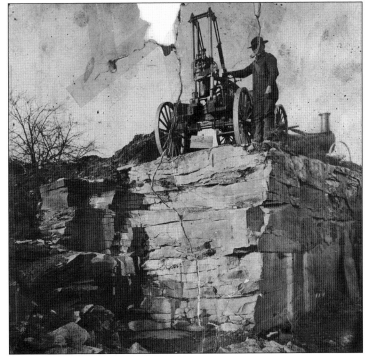

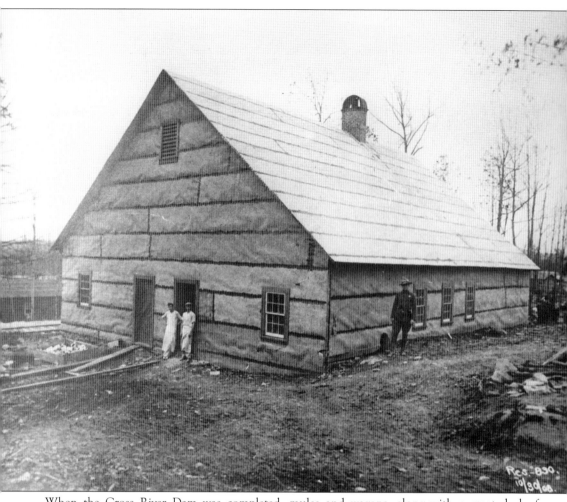

When the Cross River Dam was completed, mules and wagons, along with a great deal of laborers, made the journey to Brown's Station to find work on the Ashokan project. Initially, a great many of the workforce had to travel back and forth from Kingston because housing was not being constructed fast enough. It took most of that first fall to get dormitories built as well as the commissary, bakery, and icehouses. Seen here is the reservoir cookhouse.

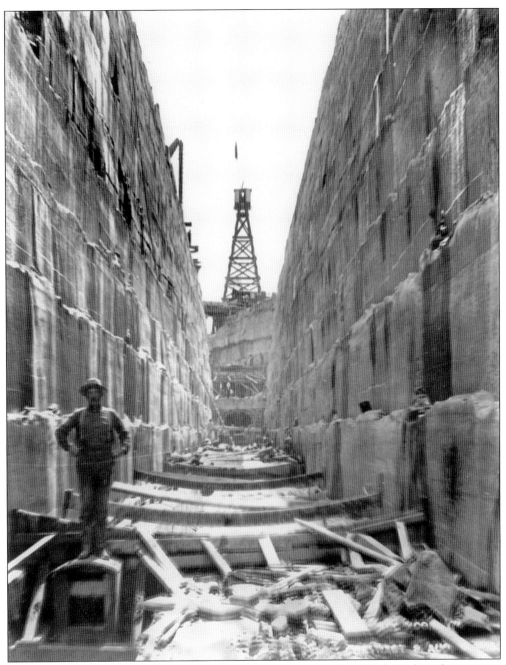

Construction increased rapidly, and a power plant, crushing plant, block yard, and temporary railroad were built. The contractors took advantage of the natural resources, using clean sand from local pits where it was used in concrete. Stone for the dam and other concrete work came from a local quarry, which had a daily output of 1,000 cubic yards.

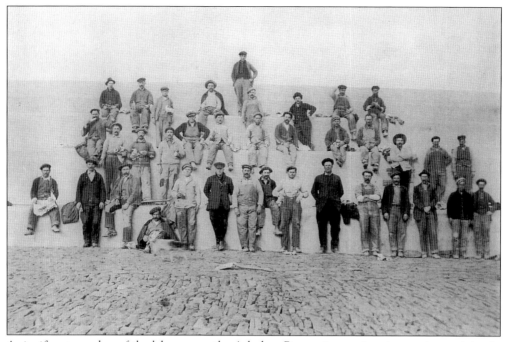

A significant number of the laborers on the Ashokan Reservoir were immigrants just arriving in the United States. African Americans came up from states in the South. Most of the Europeans were Italian, but there were also Austrians, German, Swedish, Russian, Finnish, and Polish workers as well.

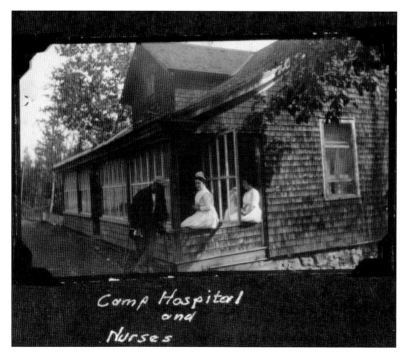

A hospital of 23 beds and attached nurses' cottages were centrally located in the camp. In the seven years of construction (1908-1915) of the entire water system, 288 people were killed and 8,839 were injured.

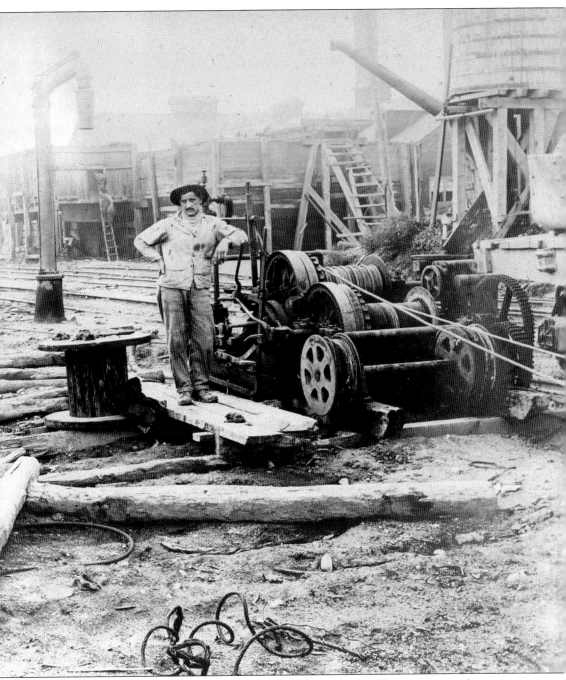

Elwyn Davis wrote about his experiences in his diaries that he kept for many years. As a young man, he would do odd jobs on the construction site of the reservoir. He worked fixing drills, engines, and steamrollers. Unfortunately, while working on one of the reservoir's steamrollers he got his hand stuck, and it was mangled. Throughout the rest of his diaries, he notes the anniversary of the incident each year.

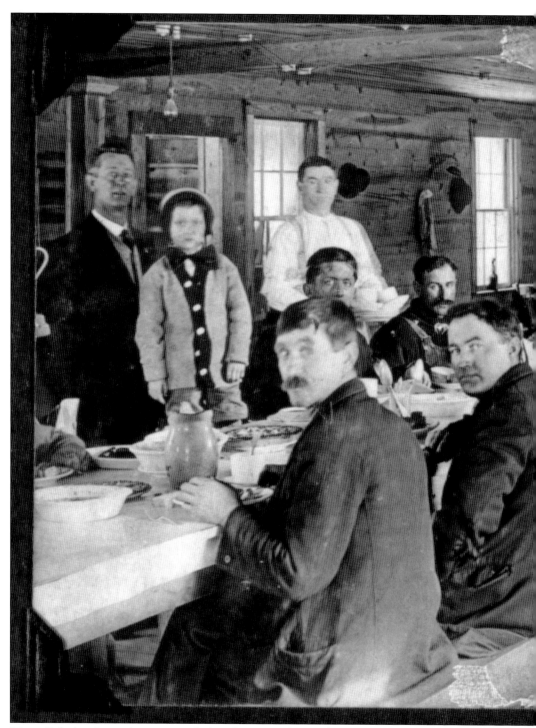

Diane Galusha gives a description of what the town of Brown's Station was transformed into in *Liquid Assets: A History of New York City's Water System*: "A temporary village was built to house, feed, educate and tend to the medical needs of up to 4,000 laborers. This camp near Brown's Station contained dormitory-style barracks, equipped with lights and running water, where single workers

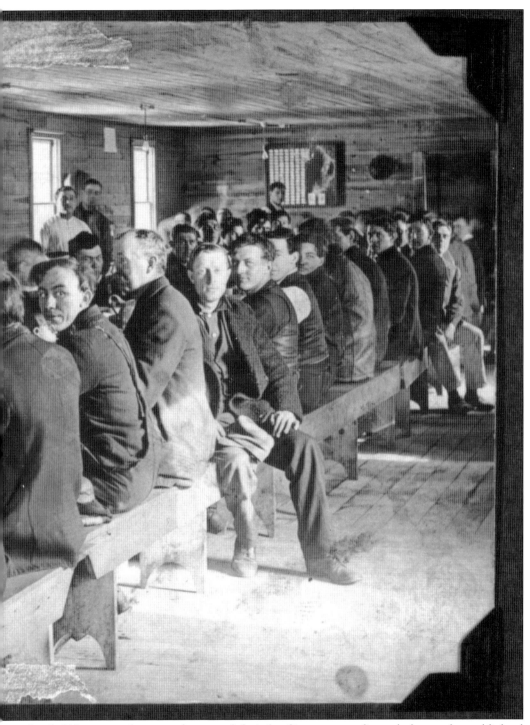

lived; 200 cottages for married men and their families; a sewage disposal plant and paved lighted streets. There was a hospital, three churches, police and fire stations, a bank, several stores, a post office, a bakery turning out 5,000 loaves of bread a day and schools."

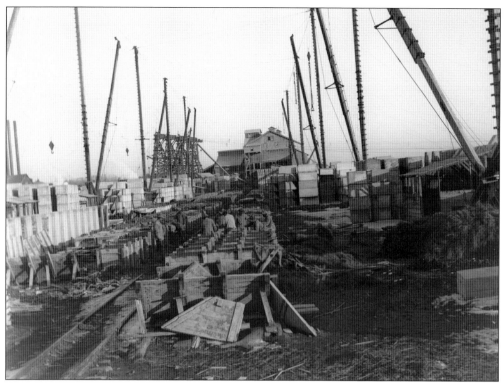

Construction of the dikes was a massive undertaking. Bob Steuding writes in *Last of the Handmade Dams* that "seven million cubic yards of earth and one million cubic yards of masonry would be used in the construction of the dam and dikes before they were finished."

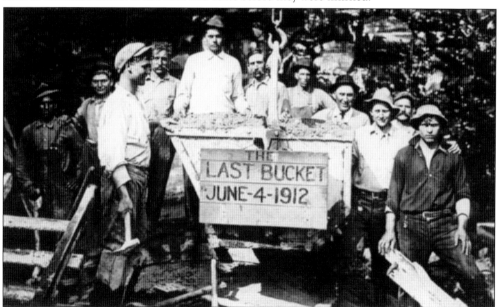

The cost of the entire Catskill Water System was $162 million, and storage of water began in September 1913. On November 22, 1915, water began to flow to New York City. When everything was completed, 300,000 tree seedlings were planted to prevent erosion.

Bob Steuding, in *Last of the Handmade Dams*, wrote that "unskilled workers on the reservoir received from $1.20 to $1.60 per day. Machinists, pipe fitters, pumpmen, and plumbers earned $2.00 per day. A stonemason would make $3.00 per day and a powderman would get $10.16 per week."

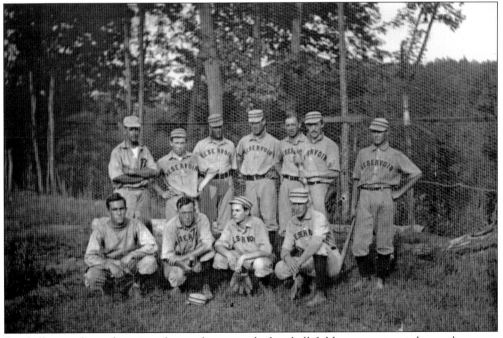

Baseball was a favored pastime for employees, and a baseball field was constructed near the camp. There was an Olivebridge, Shokan, and New York City Board of Water Supply engineers team, and at the end of the season, a silver cup was awarded to the winning team. Other amusements included a bandstand, a bowling alley, and a poolroom.

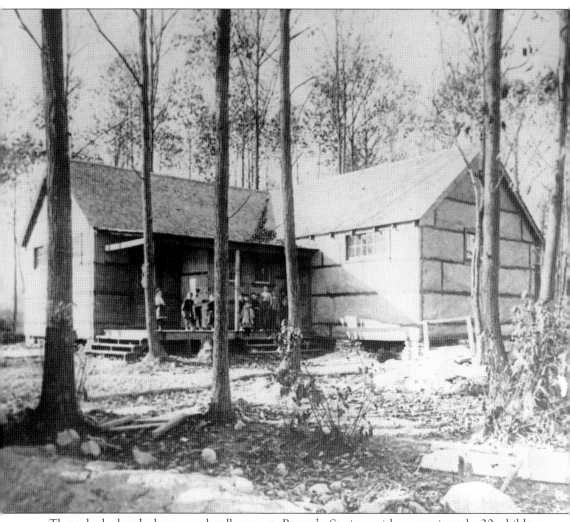

There had already been a schoolhouse at Brown's Station with approximately 20 children attending when construction began on the reservoir. As the population swelled in the camp, three more teachers were employed, and an additional school was built for the children in the main camp. Students who resided in the south wing, middle dike, and east dike camps went to already established district schools outside the camp. There were also adult classes for immigrants interested in learning the English language.

A police force was organized early on for the New York City Board of Water Supply and was comprised of a chief and four men. Their main objective was to keep alcohol out of the camp and to break up any fights that might arise. Patrolmen were paid $75 per month and had to provide their own housing. Police presence increased during World War I and II to protect the reservoir from outside forces.

In order to transport materials from plants to worksites on the reservoir a railroad was built. The railway covered 25 miles and at its height had 33 locomotives and 579 railroad cars. Pictured is a small-gauge rail line running on top of the dam.

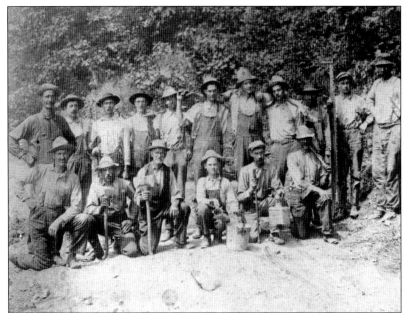

Teams of men cleared the land of all vegetation. It took these men several months to clear the west basin of trees and grub the area of any plant life. It was timed so that nothing could grow before the area was flooded.

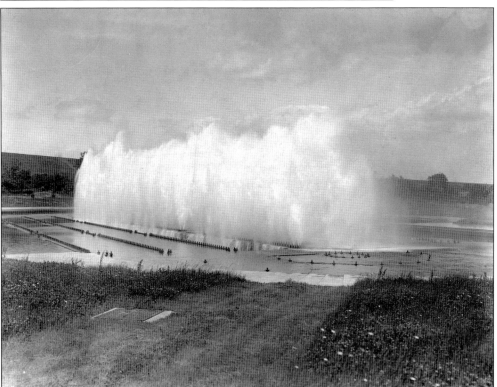

Initially, an aerator system was constructed to oxygenate and clean the water flowing to New York City. It consisted of hundreds of nozzles that would spray the water into the air to kill algae associated with stumps that were not removed from the main basin. Later, in the 1980s, a fountain would replace the aerating system, as it was deemed that algae was no longer a problem. (Courtesy of Kate McGloughlin.)

Six
A Town Moves Forward

In the years after the reservoir was constructed and many of the town's inhabitants were forced to move away, a new tradition began. Starting in 1913, each year, the Town of Olive hosted a gathering on Labor Day to have a reunion, connecting old neighbors who left to start a new life somewhere else and those who remained. The early reunions were held at Lambert's Grove, near the Traver Hollow Bridge, and consisted of a picnic, music, and storytelling.

In the 1930s, the reunion became more organized, which included a board that raised money for the event. The day would begin with a speech from the town supervisor and a prayer from a local minister, and then the storytelling and music would begin. There were mainly folk songs about the reservoir and the life they had before it was built. In those days, attendance was in the 200-to-300 range. By the early 1970s, the numbers started to dwindle with as few as 40 people attending, as those who had experienced the tragic events of the building of the reservoir slowly passed away.

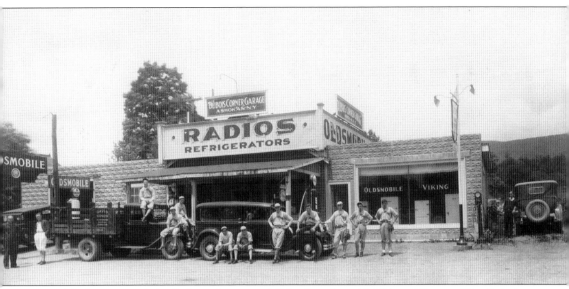

Lemuel Dubois opened the Dubois Garage in 1920, where he sold Oldsmobile cars. The Dubois family first came to the area in 1760 and settled in Brown's Station. When the reservoir was built, Lemuel's parents had to leave Brown's Station and relocate to Shokan, near where DuBois Road is now today. Lemuel was also a surveyor on the Ashokan Reservoir project, and he was town supervisor from 1936 to 1943. (Courtesy of Janette Guiliano Kahil.)

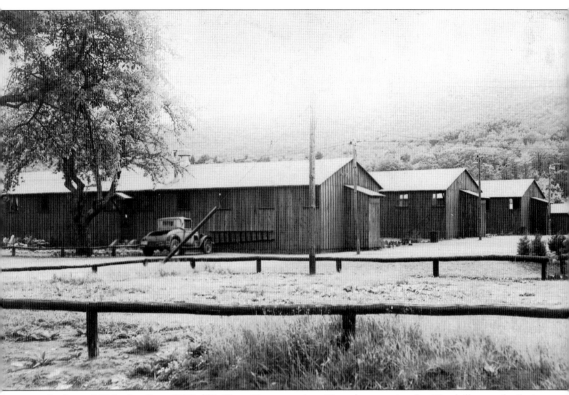

In June 1933, the first CCC (Civilian Conservation Corps) camp in the Catskills was built in Boiceville, New York. The camp was located across from where the Onteora High School is now, and 200 men resided there. Diane Galusha explains in her book *Another Day, Another Dollar: The Civilian Conservation Corps in the Catskills* that they were known as the "bug camp." This is because they oversaw the destruction of any gypsy moths they encountered among the 17,376 acres they surveyed. They also planted trees, built trails, and cleared trees for the Jay Simpson Memorial Ski Slope.

The Olive Free Library was founded in 1952 through the efforts of Claire and Joseph Friedberg. What began as an idea born in the living room of their West Shokan home became a provisional charter in 1958 and an absolute charter in 1966.

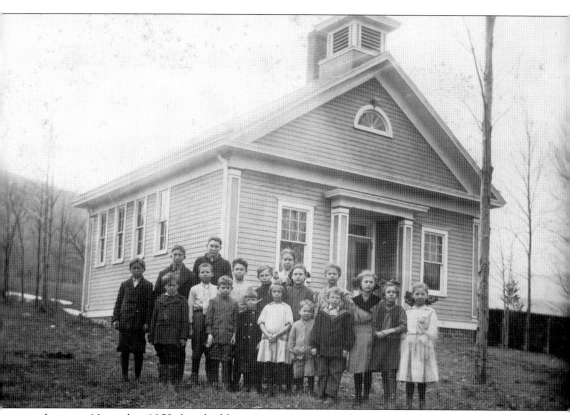

It was in November 1952 that the library committee was able to secure a location for the library. Clare and Joseph Friedberg secured the deed for the district No. 8 schoolhouse by paying $200 of their own money, which they refused to be reimbursed for.

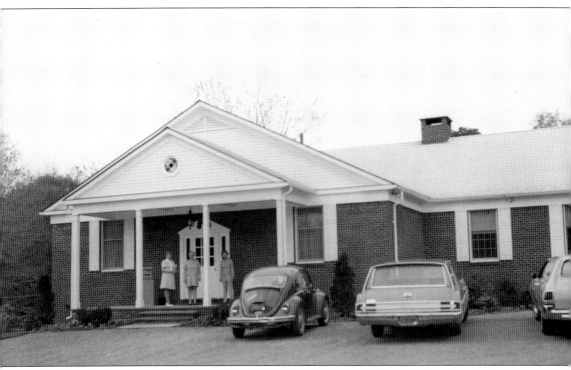

The library had its grand opening on July 11, 1953, and it was on that same date that the first art exhibition was held. The adult education program at Onteora Central School had an art class, and the students were invited to show their work at the library opening. To continue to raise funds for the new library, a card party was held the following Saturday with a 50¢ admission.

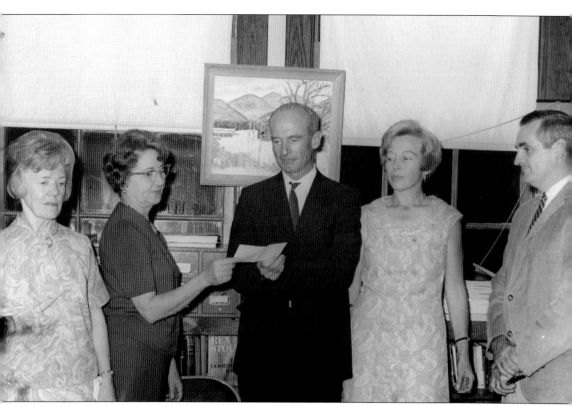

The recently vacated West Shokan School became the home of the community's first library with limited hours and donated books. With the help of the Helen Kelsey Chase family, Donald and Edna Bishop, the O'Connor Foundation, and local community members, the library welcomed its new expanded building in 1972.

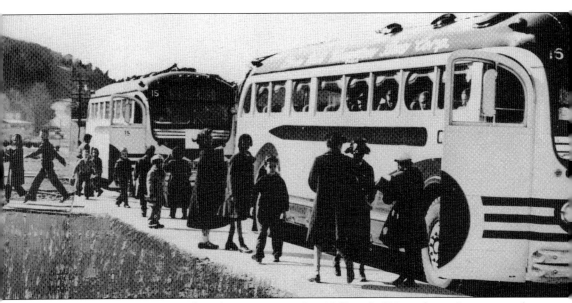

Onteora Central School opened its doors in September 1952 with 820 students. It was one of the first one-story schools in New York State. The district comprises nearly 350 square miles, and its name is derived from the Native American name meaning "Mountains of the Sky." The first superintendent was Reginald Bennett. In September 1960, the Bennett School opened its doors for students in grades first through third, and in 1963, it housed students in grades kindergarten through sixth.

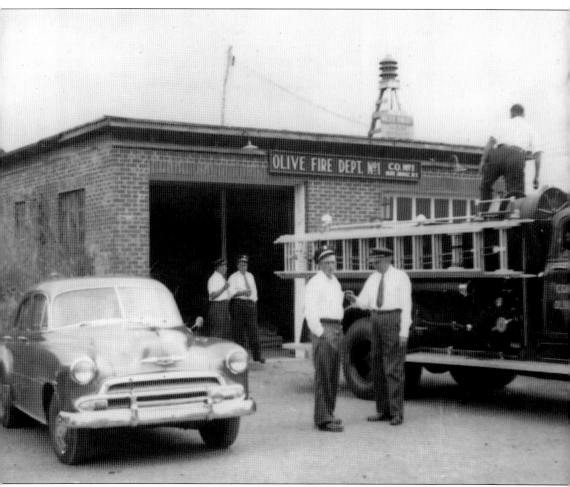

A meeting, organized by Albert S. Fox, was held on January 30, 1947, to create the first fire department in the town of Olive. The first board of directors were Percy Cook, Harlowe McLean, William Osterhoudt, Lester Barringer, Charles R. McLendon, Simeon Trowbridge, and Albert S. Fox.

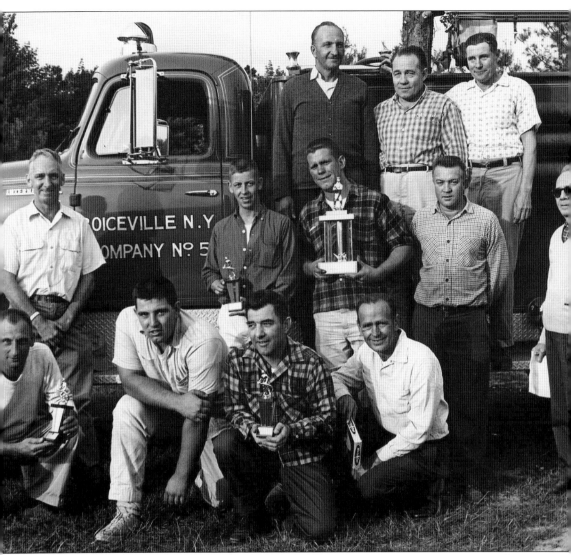

Following the success of the Olivebridge Fire Department, the Shokan company was created in 1949. The property for the station was purchased from Chester and Dorothy Lyons. Justice North, Les Lawrence, and Bob Hardy were the founders of the Shokan Fire Department. In 1952, the West Shokan Company was added, and the roster included George Reitmeyer, Deputy Chief Irv Hesley, Capt. Marcel Maier, Ray Bell, Joe Winkler, Walt Schmockle, Walt Lang, Charlie Muller, and Fred Keogan Sr. The Samsonville Fire Department followed soon after in 1954 with Deputy Chief Ernie Richert, Henry Johnson, Mo Stella, Floyd Brown, Alexander Adami, Earl Paul, Brad Kelder, Larry White, Carl Sorensen, and James Burke. Finally, in 1958, the last company was added in Boiceville, with Chief Bill Doing and fellow officers Ray Mercier, Joe Bonesio, and Willie John at the helm.

During the late 1950s, the area's population was booming, and there became a need for an additional school building to house students from kindergarten through sixth grade. The Bennett School dedication occurred on January 15, 1961, and although the community thought that would solve their growing demands, the Phoenicia and West Hurley schools were also constructed to meet the educational needs of the community.

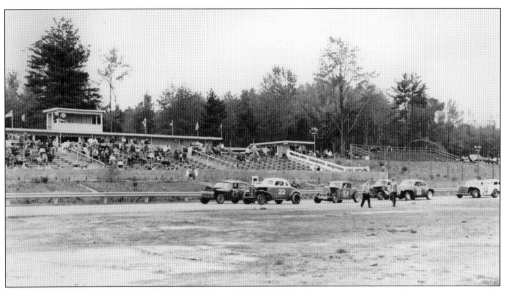

The Onteora Speedway opened on August 14, 1960, to a crowd of almost 5,000 spectators, and the purse was $1,700. The officers of the corporation were Richard L. Lane, Raymond Davis, Larry Shurter, and H. Edgar Timmerman. It was a banked half-mile dirt track built on a 65-acre plot located on Route 213 in Olivebridge. The track had several successful years before closing in 1967. (Courtesy of Mavis and Raecine Shurter.)

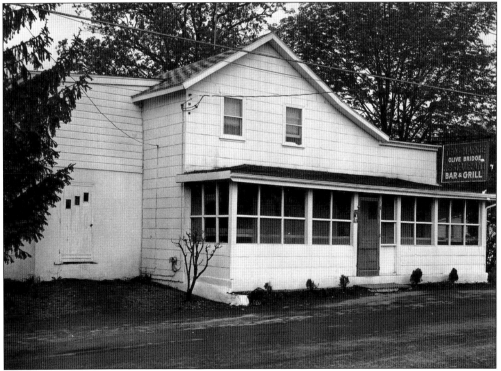

After the races, one might find oneself across the street at Shurter's Tavern, run by Mavis and Larry Shurter. According to Raecine, their daughter, and Donnie Beesmer, a local resident, people would be four deep at the bar, and pizzas could be purchased for $1.

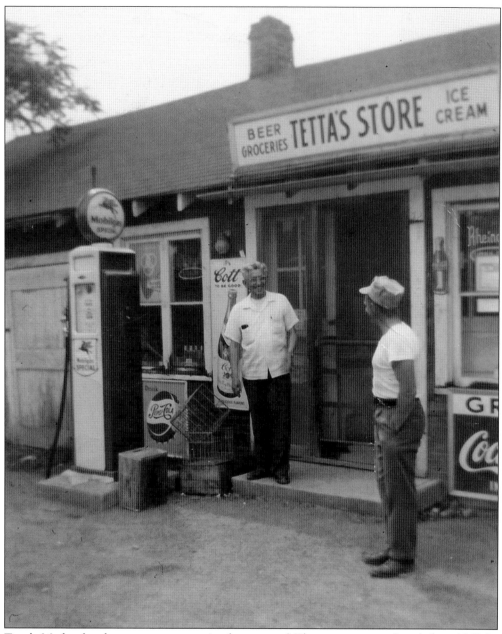

Tetta's Market has been a cornerstone in the town of Olive since it was founded in 1952 by Joseph Tetta. Originally from the Bronx, Tetta would spend weekends upstate before moving to Samsonville permanently to open the business. In 1971, Tetta's son, Fred, alongside his wife, Ana, took over the store and ran it for nearly 50 years until their grandson, Primo Stropoli, purchased it in 2019. (Courtesy of Primo Stropoli.)

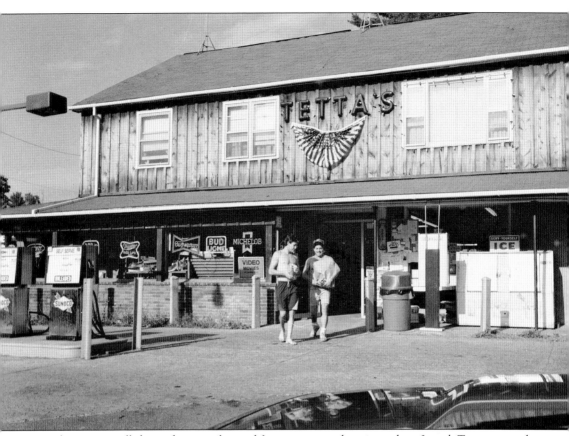

Tetta's was originally located just up the road from its current location, where Joseph Tetta operated the business for nearly a decade out of a small two-car garage that he rented. Then, in 1961, Tetta purchased land at the intersection of County Roads 2 and 3 and erected a new building. When Fred and Ana took over, they constructed several additions, and the building remained the same until Primo and his father, Richard, renovated the property once again. Now, four generations later, Tetta's continues to be a hub for the community, with Primo at its helm. (Courtesy of Primo Stropoli.)

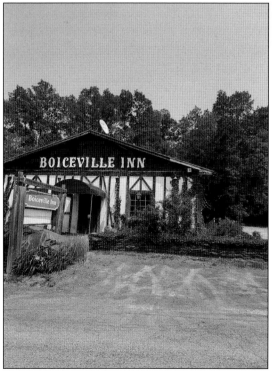

The Boiceville Inn was not always located in its current location. It began in the building that housed the former Landmark restaurant in the center of Boiceville. In 1946, the Tosi family purchased the property and lived upstairs. The building housed both a restaurant and a general store.

The current Boiceville Inn was built in 1973 by John Parete. Many community members participated in its construction. The lumber came from Shurter's mill and from an old barn on the Kelder property. The bar was built by Carl Lane, and Marty and Dino Guiliano did the excavation work. Johnny Bachor wired the electric, Hoppy Quick put the roof on, and Buddy Eckert did the insulation work.

In the 1950s and 1960s, Olivebridge was a bustling hamlet. It included Nelson Boice's grocery, Ethel Gray's grocery, Arnosky meat market, Shurter's Tavern, a post office, Ollie Crawford's garage, and of course, the first fire station in the town.

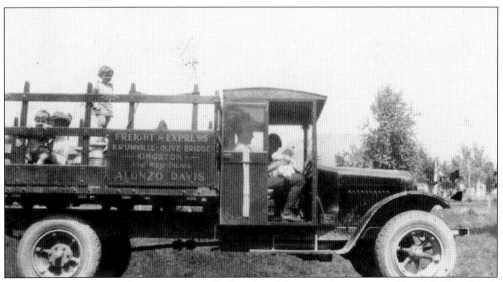

Davis Express was created to transport milk from local farms to the creamery. Kate McGloughlin's grandmother, Viva Davis, drove the truck, and on the way back, she delivered blocks of ice and coal to Ethel Gray's store. (Courtesy of Kate McGloughlin.)

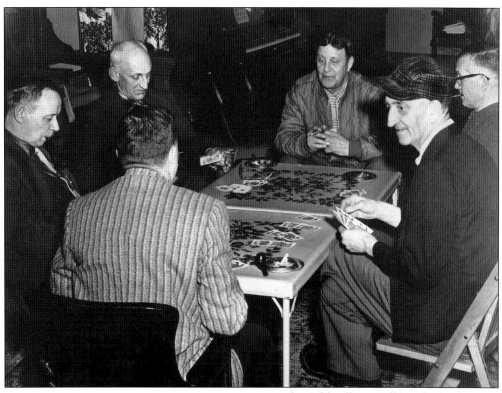

The Odd Fellows Hall in Olivebridge was a popular hangout. There were community suppers held there as well as dances and the biweekly pinochle game after the lodge meeting. (Courtesy of Kate McGloughlin.)

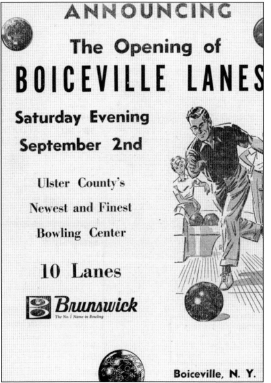

Boiceville was relocated to its current location after the construction of the Ashokan Reservoir. It began to grow rapidly as its population increased, and in the 1950s, there was the newly constructed Onteora Central School, Minervini's Restaurant, the original Boiceville Inn, and a nursery. In the late 1950s and early 1960s, a grocery store, Dino's Drive-In, Boiceville Lanes, and Singer and Denman Lumber were added.

Born in 1874 in Chateauneuf de Chabre, France, Emile Brunel first came to America in 1904. In Jersey City, New Jersey, he opened a movie studio with Cecil B. Demille and became a respected portrait photographer with over 35 photographic studios across the Northeast. He founded what is now the New York Institute of Photography in 1913. He made his fortune honing and developing the one-hour photo process—revolutionizing the film industry and allowing productions to view footage shot the same day. (Courtesy of Brunel Park.)

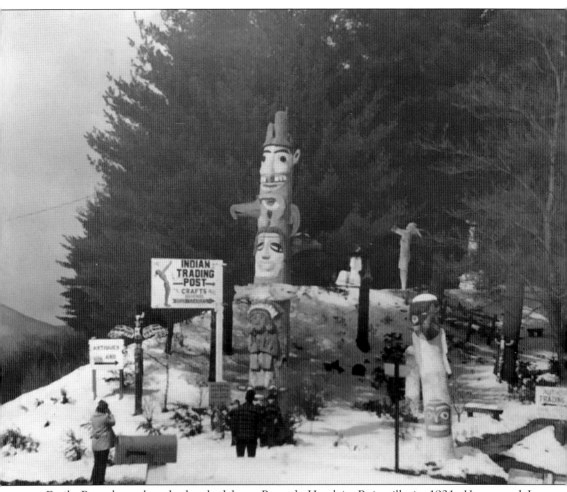

Emile Brunel purchased what had been Brown's Hotel in Boiceville in 1921. He opened Le Chalet Indien, and during the following 20 years, he constructed 14 concrete statues, totems, and bas-reliefs that reflected his love of Native American peoples. This is now known as the Brunel Sculpture Garden. The chalet was operational from the late 1920s to the late 1950s. According to its current owners, Cynthia and Evgeny Nitkin, Chalet Indien drew luminaries from the arts, politics, and cultural life, such as Franklin D. and Eleanor Roosevelt, Max Ernst, Irving Berlin, Enrico Caruso, Frederick Kiesler, Harold Prince, and numerous others who shaped modern life around the world. (Courtesy of Brunel Park.)

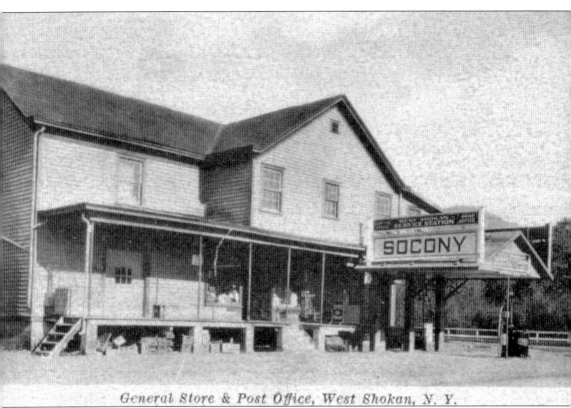

General Store & Post Office, West Shokan, N. Y.

West Shokan was perhaps the most altered by the construction of the reservoir. It had been a bustling little town full of commercial buildings, a train station, hotels, and Pythian Hall. In the years that followed the town's destruction and relocation, businesses located here were Skin Davis's General Store, Colange's General Store, Snyder's Tavern, Watson Hollow Inn, the Holiday Inn, and the West Shokan Garage.

Shokan, with a closer proximity to the new Route 28, was bustling with activity. There was Joe Elefant's Ashokan General Store, Haver's Ford Garage, Sal Giordano's General Store, Winchell Corners General Store, Suburban Casuals, and Crisafulli Barber, to name a few.

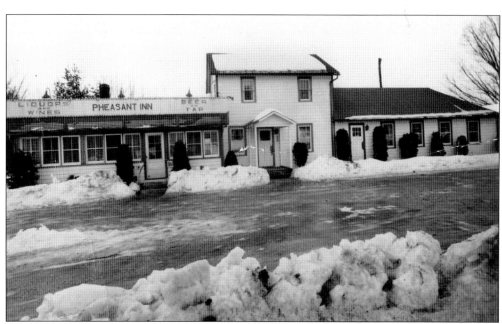

In the 1950s and 1960s, there were plenty of choices when it came to grabbing something to eat in Shokan. There was the Orchard Rest Bar, Bel Aire Diner, Hank and Sarah DeWitt's Tavern, and the Pheasant Inn.

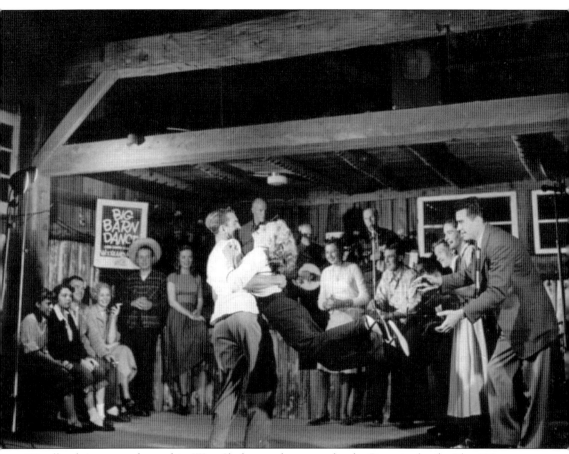

Woodland Acres was located in West Shokan and was run by the Brattain family. The 100-acre resort offered barn dances, fishing, hayrides, and other amusements to visitors mainly coming up from New York City. The party package weekend for $25 included private bus transportation to and from New York City, a barbecue and barn dance, meals, and accommodations.

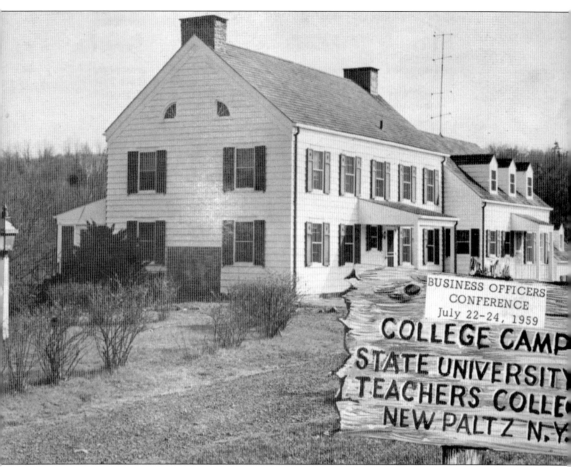

The Ashokan Center was originally the Ashokan Field Campus and was operated by SUNY New Paltz under the guidance of Kent Reeves. He developed the first "Living History" program in the state, which ran from 1967 to 2008.

The Ashokan Center, established in 2008, welcomes school groups for educational field trips; hosts public community events, including festivals and music and dance camps; and rents its facility for private retreats, conferences, and weddings. Its site has been declared a Historic District in the National and State Registers of Historic Places. The first mill and blacksmith shop in Ulster County were built here by Lemuel Winchell, who later constructed Winchell's Inn.

Snyder's Tavern, a local landmark, was originally called the Traver Hollow Inn in 1928. It was then owned by Arthur and Mabel Snyder and operated as a boardinghouse. It is said to have the longest continuous liquor license in New York state. It was awarded the license in 1933 when Prohibition was repealed. In later years, it was owned by the Snyders' daughter Jane and is now run by her son Chet Scofield.

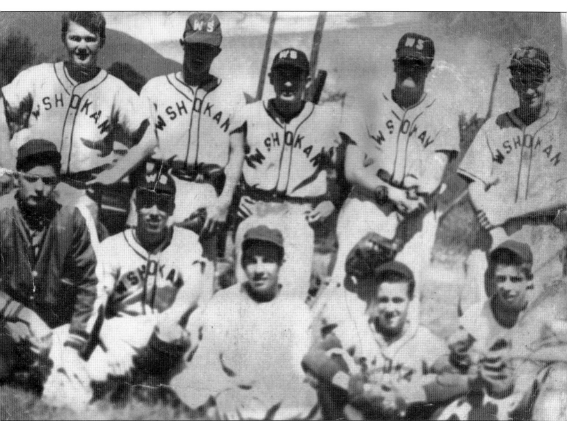

Baseball was a popular pastime even in pre-reservoir times. During the construction of the reservoir, the laborers had their own team. In later years, the West Shokan Baseball Club was called the Bushkill Wildcats, and the other teams in the league were Hurley, Samsonville, and Shokan. Bud Eckert was the team manager for the Bushkill Wildcats, and he is pictured here wearing a satin manger's baseball jacket. (Courtesy of Janette Guiliano Kahil.)

Discover Thousands of Local History Books
Featuring Millions of Vintage Images

Arcadia Publishing, the leading local history publisher in the United States, is committed to making history accessible and meaningful through publishing books that celebrate and preserve the heritage of America's people and places.

Find more books like this at
www.arcadiapublishing.com

Search for your hometown history, your old stomping grounds, and even your favorite sports team.

Consistent with our mission to preserve history on a local level, this book was printed in South Carolina on American-made paper and manufactured entirely in the United States. Products carrying the accredited Forest Stewardship Council (FSC) label are printed on 100 percent FSC-certified paper.